Wisdom With Understanding is Better Than Rubies

Lurine Karon Greenberg
Fine Arts Collection

THE BIG BOOK OF
tiny art

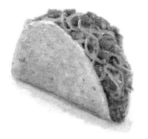

A modern, inspirational guide
to the art of the miniature

Brimming with creative inspiration, how-to projects, and useful information to enrich your everyday life, Quarto Knows is a favorite destination for those pursuing their interests and passions. Visit our site and dig deeper with our books into your area of interest: Quarto Creates, Quarto Cooks, Quarto Homes, Quarto Lives, Quarto Drives, Quarto Explores, Quarto Gifts, or Quarto Kids.

Inspiring | Educating | Creating | Entertaining

First Published in 2016 by Walter Foster Publishing, an imprint of The Quarto Group.
6 Orchard Road, Suite 100, Lake Forest, CA 92630, USA.
T (949) 380-7510 **F** (949) 380-7575 **www.QuartoKnows.com**

Artwork and photographs © 2016 Karen Libecap, except:
Artwork and photographs on pages 10, 11, 12 ("Watercolor Paints," "Acrylic & Oil"),
13, and 14-23 © 2014 Elizabeth T. Gilbert; and photograph on page 12 ("Gouache") © Shutterstock.
Borders and frames on pages 46-79, 102-123, 144-171, and 192-205 © Shutterstock.

Author photograph on page 208 by Leah Karol.

Acquiring & Project Editor: Stephanie Carbajal
Page Layout: Krista Joy Johnson

Walter Foster Publishing titles are also available at discount for retail, wholesale, promotional, and bulk purchase. For details, contact the Special Sales Manager by email at specialsales@quarto.com or by mail at The Quarto Group, Attn: Special Sales Manager, 401 Second Avenue North, Suite 310, Minneapolis, MN 55401 USA.

ISBN: 978-1-63322-179-6

Printed in China
3 5 7 9 10 8 6 4

THE BIG BOOK OF
tiny art

A modern, inspirational guide
to the art of the miniature

Karen Libecap

TABLE OF CONTENTS

INTRODUCTION

Artists have been working in miniature since the early 16th century, and it is an art form that continues to evolve and transform over time. Miniature art is often extremely detailed, despite the small size of the subjects. A fine miniature work of art can be magnified many times and still retain its integrity.

In the pages that follow you'll discover how to draw and paint miniature art covering a wide range of subjects, from animals and food to people and fun objects. Like any other art form, working in miniature requires a bit of practice and patience to perfect your skill. If you follow the tips and instruction in this book, you'll be well on your way to creating your own tiny masterpieces.

IF YOU FOLLOW THE TIPS, TECHNIQUES, AND INSTRUCTION IN THIS BOOK, YOU'LL BE WELL ON YOUR WAY TO CREATING YOUR OWN TINY MASTERPIECES.

Most of the artwork in this book has been completed with a combination of watercolor paint and colored pencil, but you can use the concepts and easy-to-follow instructions to create artwork in the medium of your choice. From acrylic and oil to pastel and gouache, you can create miniature artwork however you choose. You'll find tips and techniques for working with some of these mediums on pages 10–21.

This book is divided into four sections: Tiny Animals, Tiny Food & Drink, Tiny Things & People, and Tiny Places. You'll find step-by-step tutorials for drawing and painting everything from a sweet lamb to an underwater scene. Ready to get started?

THE ARTIST'S PROCESS

It's always a challenge to recreate lifelike detail in a tiny area. I use watercolor, gouache, colored pencils, and even oils to achieve the desired effects I want. Smaller than a large coin, each of my illustrations celebrates tiny art and big ideas. Each miniature work presents a new challenge that allows me the opportunity to stretch myself as an artist. I hope you'll find the same satisfaction and creative fulfillment on your own artistic journey!

GETTING STARTED

I create all of my tiny paintings and drawings within a 1¼" x 1¼" square on a 5-inch square piece of hot-pressed watercolor paper. Create guidelines for your artwork by measuring and marking the art space lightly in pencil. When you're done, you can erase the guidelines.

STARTING WITH A SKETCH

The key to any great work of art—especially a miniature—is starting with a good sketch. I use a pencil to lightly sketch the general shapes and outline of the subject. There's no need to focus on detail at this stage. This is the time to make sure proportions and perspective are accurate before applying color.

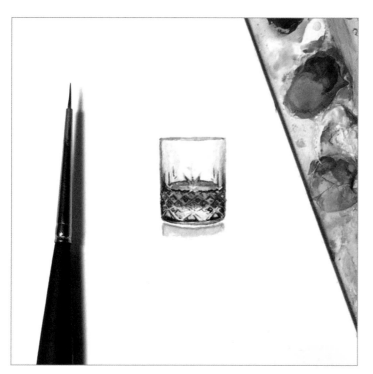

CREATING DETAIL

Using a steady hand and a set of precise tools, I render texture with calculated placement of shadows and quick, fine brushstrokes. The end result is detailed artwork created in vibrant colors that "pop" off the page.

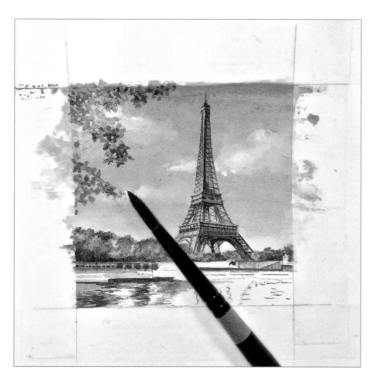

MAINTAINING CONSISTENCY

My tiny paintings are done in a realistic style. Each painting or drawing either stands alone with a shadow or is framed by a circle or square. Keep the same style throughout. Your style may not be as realistic or detailed as mine, and that's okay! As long as there is some consistency in size and style, the subject matter can be anything you like, and it will look great as a body of work.

TOOLS & MATERIALS

You can create miniature art using any number of art tools and mediums. While most of the tutorials and gallery artwork in this book are done in watercolor and colored pencil, you can also use other types of paints, pens, or even just graphite pencils.

PENCILS Drawing pencils are labeled according to the hardness of the graphite. H pencils are hard; they contain a higher ratio of clay to graphite and produce a light gray line. B pencils are soft; they contain a higher ratio of graphite to clay and produce softer, darker lines. The higher the number that accompanies the letter, the harder or softer that lead is. F and HB (which is the lead of a common "number 2" pencil) are considered neither hard or soft.

ERASERS There are many eraser options; shown here are two that work well for working in small areas. Stick erasers are pencil-like barrels that hold a long cylinder of soft vinyl eraser. You can use a craft knife to shape the tip for even more precision. An electric eraser is a handheld, battery-powered tool that spins a small stick eraser, eliminating the need to rub.

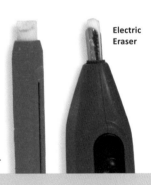

Electric Eraser

Stick Eraser

PENCIL HARDNESS

8B

4B

HB

4H

Pictured here are gradations of 8B, 4B, HB, and 4H leads over medium drawing paper, allowing you to see differences in stroke quality and darkness.

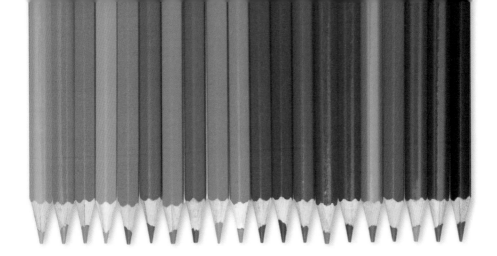

COLORED PENCILS Colored pencil leads are made of pigment and wax or kaolin clay. Wax is more common and affordable. Wax leads are soft and allow for smooth, controlled blends. When working with wax-based pencils, your work may develop *bloom*—a light fog over the drawing as a result of wax rising to the surface. To eliminate this, let the drawing sit for two weeks, and then rub a tissue, cotton ball, or cotton pad over the blooms to catch and remove the wax.

ARTIST TAPE This mildly tacky tape (usually white, off-white, or blue) is ideal for mounting your paper to a drawing surface to keep it in place. It's also perfect for marking off the appropriately sized drawing or painting space on the paper for your miniature art. The tape will not damage the paper upon removal.

Artist Tape

SHARPENER When you're working in the miniature, it's very important to keep pencil tips sharp. Keep your favorite pencil sharpener nearby so you can quickly and easily sharpen any graphite or colored pencil while you work.

TORTILLON Tortillons are made of tightly rolled paper. You can use tortillons or blending stumps to smooth graphite.

Tortillon

WATERCOLOR PAINTS Watercolor paint is made up of pigment suspended in a binder of gum arabic. This fluid medium requires a bit of practice to master, however with a bit of practice you can suggest form and color with just a few brushstrokes. You can purchase watercolor paints in tubes, pans, and pots. You can even use watercolor pencils, which are a great option for maintaining control.

GOUACHE Gouache is essentially a highly pigmented version of watercolor with slightly larger pigment particles and chalk additive. The opaque, chalky quality of gouache gives the paint a matte sheen and a soft, flat appearance. Like watercolors, gouache is also available in tubes and lidded pots.

ACRYLIC & OIL Acrylic is a water-based paint that boasts a number of positive qualities. You can dilute acrylic paint with water for thin washes and light application. Acrylic paint dries quickly, so you need to work quickly if you want to blend on the paper or canvas. Oil paint is slow drying, but it is not water-based, so you'll need special liquids for thinning the paint and cleaning your brushes.

PAINTBRUSHES A wide range of brush types and sizes are available. For painting in the miniature, you'll want to have a selection of small paintbrushes on hand. Brushes come in three basic hair types: soft natural-hair, soft synthetic-hair, and bristle brushes. Natural-hair brushes are a good choice for watercolor paint, while synthetic-hair brushes are ideal for acrylics or watercolor. Bristle brushes are coarse and sturdy for working with thick oil and acrylic paint.

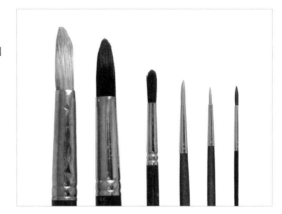

PALETTE Mixing palettes come in a wide variety of materials, shapes, and sizes. A simple welled palette is a great choice for working with fluid mediums like watercolor and gouache. White plastic palettes are lightweight and easy to clean, and they also allow the artist to better judge their paint colors and mixes as they will appear on white paper.

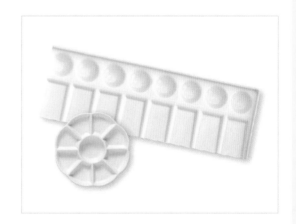

PAPER Paper comes in a variety of formats. Drawing paper is ideal for working in graphite or colored pencil. This kind of paper varies in weight, from 50 lb. to about 106 lb. Thin papers between 50 lb. and 64 lb. are great for sketching, whereas heavier weights can withstand more erasing and are appropriate for serious drawing. Watercolor paper is the perfect surface, not only for fluid washes of watercolor, but for other wet and dry media, including gouache, acrylic, pastel, pen and ink, and even graphite. Like drawing paper, watercolor paper varies in weight, and it is available in three textures: hot-pressed (smooth), cold-pressed (textured), and rough (very textured).

GRAPHITE TECHNIQUES

The way you apply a medium to paper contributes to the overall mood and style of a piece. Arm yourself with a variety of effects by getting to know the following techniques. You can use many of these techniques for other dry media, such as charcoal and pastel.

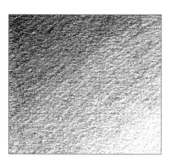

GRADATING WITH PRESSURE

A gradation is a transition of tone from dark to light. To create a simple gradation using one pencil, begin with heavier pressure and gradually lighten it as you stroke back and forth. Avoid pressing hard enough to score or completely flatten the tooth of the paper.

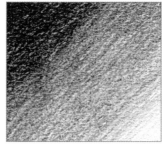

GRADATING WITH HARDNESS

Because different pencil hardnesses yield different values, you can create a gradation by using a series of pencils. Begin with soft, dark leads and switch to harder, grayer tones as you move away from the starting point.

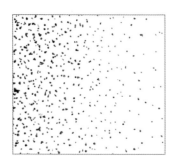

STIPPLING

Apply small dots of graphite for a speckled texture. To prevent this technique from appearing too mechanical, subtly vary the dot sizes and distances from each other.

SCUMBLING

This organic shading method involves scribbling loosely to build up general tone. Keep your pressure light and consistent as you move the pencil in random directions.

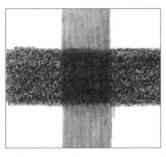

BURNISHING
It is difficult to achieve a very dark tone with just one graphite pencil, even when using a soft lead. To achieve a dark, flat tone, apply a heavy layer of soft lead followed by a layer of harder lead. The hard lead will push the softer graphite into the tooth of the paper, spreading it evenly. Shown above is 4H over 4B lead.

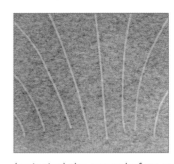

INDENTING
To preserve fine white lines in a drawing, such as those used to suggest whiskers, some artists indent (or incise) the paper before applying tone. Use a stylus to "draw" your white lines; then stroke your pencil over the area and blend. The indentations will remain free of tone.

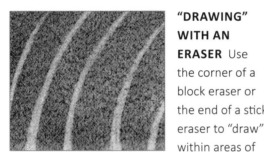

"DRAWING" WITH AN ERASER Use the corner of a block eraser or the end of a stick eraser to "draw" within areas of tone, resulting in light strokes. You can use this technique to recover lights and highlights after blending.

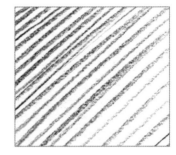

HATCHING
Hatching is considered one of the simplest forms of shading. Simply apply a series of parallel lines to represent darker tones and shadows. The closer together you place the lines, the darker the shading will appear.

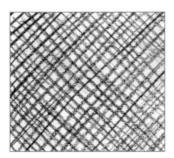

CROSS-HATCHING
Place layers of parallel lines over each other at varying angles. This results in a "mesh" of tone that gives shaded areas a textured, intricate feel. For depth, make the lines follow the curves of your object's surface.

ARTIST TIP

WHEN WORKING WITH AN ERASER THAT LEAVES BEHIND CRUMBS, KEEP A BLOW BULB OR A LARGE, SOFT BRUSH ON HAND TO CLEAN YOUR PAPER.

COLORED PENCIL TECHNIQUES

Colored pencils are capable of conveying a diverse mix of textures, color densities, and finished looks. If your style leans toward sketches, use cold-pressed paper and bolder strokes with less layering. If you like a highly polished look, use hot-pressed paper and lots of layers.

VARYING STROKES
Experiment with the tip of your pencil as you create a variety of marks, from tapering strokes to circular scribbles.

GRADATING
To create a gradation with one color, stroke side to side with heavy pressure and lighten your pressure as you move away, exposing more of the white paper beneath the color.

ARTIST TIP

COLORED PENCIL DOES NOT LIFT FROM THE PAPER AS EASILY AS GRAPHITE OR CHARCOAL; SOME RESIDUE WILL ALMOST ALWAYS STAY BEHIND. IF YOU MUST ERASE, AN ELECTRIC VINYL ERASER WILL DELIVER THE BEST RESULTS.

LAYERING You can optically mix colored pencils by layering them lightly on paper. In this example, observe how layering yellow over blue creates green.

BLENDING To blend one color into the next, lighten the pressure of your pencil and overlap the strokes where the colors meet.

HATCHING & CROSS-HATCHING Add shading and texture to your work with hatching (parallel lines) and crosshatching (layers of parallel lines applied at varying angles).

STIPPLING Apply small dots of color to create texture or shading. The closer together the dots, the darker the stippling will "read" to the eye.

BURNISHING Colored pencil catches in the tooth of the paper, therefore the layers can appear rough. For a smooth, shiny effect, burnish the layer by stroking over it with a colorless blender, a white colored pencil (to lighten), or another color (to shift the hue) using heavy pressure. Burnishing pushes the color into the tooth and distributes the pigment for smooth coverage.

WATERCOLOR TECHNIQUES

Practice these techniques to get comfortable with the behavior of watercolor paint.

FLAT WASH A flat wash is a thin layer of paint applied evenly to your paper. First wet the paper, and then load your brush with a mix of watercolor and water. Stroke horizontally across the paper and move from top to bottom, overlapping the strokes as you progress.

GRADATED WASH A gradated (or graduated) wash moves slowly from dark to light. Apply a strong wash of color and stroke in horizontal bands as you move away, adding water to successive strokes.

BACKRUNS Backruns, or "blooms," create interest within washes by leaving behind flower-shaped edges where a wet wash meets a damp wash. First stroke a wash onto your paper. Let the wash settle for a minute or so, and then stroke another wash within (or add a drop of pure water).

WET-INTO-WET Stroke water over your paper and allow it to soak in. Wet the surface again and wait for the paper to take on a matte sheen; then load your brush with rich color and stroke over your surface. The moisture will grab the pigments and pull them across the paper to create feathery, soft blends.

APPLYING WITH A SPONGE In addition to creating flat washes, sponges can help you create irregular, mottled areas of color.

SPATTERING First cover any area you don't want to spatter with a sheet of paper. Load your brush with a wet wash and tap the brush over a finger to fling droplets of paint onto the paper. You can also load your brush and then run the tip of a finger over the bristles to create a spray.

DRYBRUSHING Load your brush with a strong mix of paint, and then dab the hairs on a paper towel to remove excess moisture. Drag the bristles lightly over the paper so that tooth catches the paint and creates a coarse texture. The technique works best when used sparingly and with opaque pigments over transparents.

USING SALT For a mottled texture, sprinkle salt over a wet or damp wash. The salt will absorb the wash to reveal the white of the paper in interesting starlike shapes. The finer the salt crystals, the finer the resulting texture. For a similar but less dramatic effect, simply squirt a spray bottle of water over a damp wash.

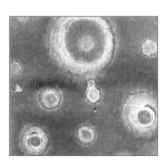

USING ALCOHOL To create interesting circular formations within a wash, use an eyedropper to drop alcohol into a damp wash. Change the sizes of your drops for variation.

TILTING To pull colors into each other, apply two washes side by side and tilt the paper while wet so one flows into the next. This creates interesting drips and irregular edges.

ACRYLIC & OIL TECHNIQUES

These examples are done in acrylic paint, but the techniques are the same for both oil and acrylic.

FLAT WASH Thin the paint and stroke it evenly across your surface. For large areas, stroke in overlapping horizontal bands, retracing strokes when necessary to smooth out the color.

GLAZING You can apply a thin layer of acrylic or oil over another color to optically mix the colors. Shown here are ultramarine blue (left) and lemon yellow (right) glazed over a mix of permanent rose and Naples yellow.

STIPPLING The closer the dots, the finer the texture and the more the area will take on the color and tone of the stippled paint. You can also use stippling to optically mix colors; for example, stippling blue and yellow in an area can create the illusion of green.

WIPING AWAY Use a soft rag or paper towel to wipe away wet paint. You can use this technique to remove mistakes or to create a design within your work. Some pigments are more staining and will leave behind more color than others.

DRYBRUSHING Load your brush and then dab the bristles on a paper towel to remove excess paint. Drag the bristles lightly over your surface so that the highest areas of the canvas or paper catch the paint and create a coarse texture.

DABBING Load your brush with thick paint and then use press-and-lift motions to apply irregular dabs of paint to your surface. For more depth, apply several layers of dabbing, working from dark to light. Dabbing is great for suggesting foliage and flowers.

SCUMBLING This technique refers to a light, irregular layer of paint. Load a brush with a bit of slightly thinned paint, and use a scrubbing motion to push paint over your surface. When applying opaque pigments over transparents, this technique creates depth.

SPONGING Applying paint by dabbing with a sponge can create interesting, spontaneous shapes. Layer multiple colors to suggest depth. Remember that you can also use sponges to apply flat washes with thinned paint.

GRADUATED BLEND To create a gradual blend of one color into another, stroke the two different colors onto the canvas horizontally, leaving a gap between them. Continue to stroke horizontally, moving down with each stroke to pull one color into the next. Retrace your strokes where necessary to create a smooth blend between colors.

SPATTERING First cover any area that you don't want to spatter with a sheet of paper. Load your brush with thinned paint and tap it over a finger to fling droplets of paint onto the paper. You can also load your brush and then run a fingertip over the bristles to create a spray.

COLOR THEORY BASICS

Acquaint yourself with the ideas and terms of color theory, which involve everything from color relationships to perceived color temperature and color psychology.

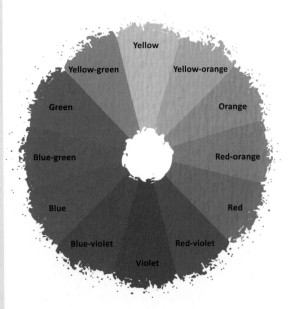

THE COLOR WHEEL

The color wheel is the most useful tool for understanding color relationships. Where the colors lie relative to one another can help you group harmonious colors and pair contrasting colors to communicate mood or emphasize your message. The wheel can also help you mix colors efficiently. Below are the most important terms related to the wheel.

Primary colors are red, blue, and yellow. With these you can mix almost any other color; however, none of the primaries can be mixed from other colors. *Secondary* colors include green, orange, and violet. These colors can be mixed using two of the primaries. (Blue and yellow make green, red and yellow make orange, and blue and red make violet.) A *tertiary* color is a primary mixed with a near secondary, such as red with violet to create red-violet.

COMPLEMENTARY COLORS

Complementary colors are those situated opposite each other on the wheel, such as purple and yellow. Complements provide maximum color contrast.

ANALOGOUS COLORS

Analogous colors are groups of colors adjacent to one another on the color wheel, such as blue-green, green, and yellow-green. When used together, they create a sense of harmony.

NEUTRAL COLORS

Neutral colors are browns and grays, both of which contain all three primary colors in varying proportions. Neutral colors are often dulled with white or black.

HUE

A **A** B C D

A *hue* is a color in its purest form (A), a color plus white is a *tint* (B), a color plus gray is a *tone* (C), and a color plus black is a *shade* (D).

COLOR FAMILY

A B C

A single color family, such as blue, encompasses a range of hues—from yellow-leaning (A) to red-leaning (C).

COLOR & VALUE

Within each hue, you can achieve a range of values—from dark shades to light tints. However, each hue has a value relative to others on the color wheel. For example, yellow is the lightest color and violet is the darkest. To see this clearly, photograph or scan a color wheel and use computer-editing software to view it in grayscale. It's also very helpful to create a grayscale chart of all the paints in your palette so you know how their values relate to one another.

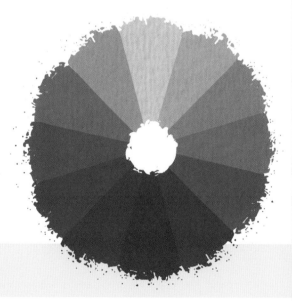

A grayscale representation of a color wheel can help you see the inherent value of each hue.

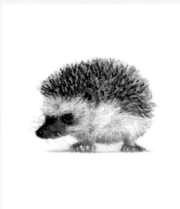

TINY ANIMALS

FOX

The secret to rendering realistic fur texture is to develop it in layers of strokes. Give it a try and create your own miniature fox.

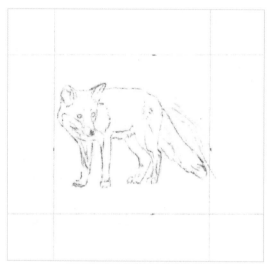

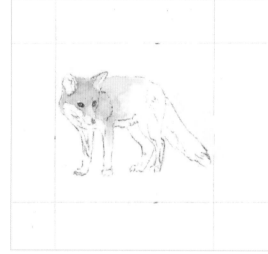

STEP 1

Measure a 1¼" x 1¼" square, and lightly sketch the general shapes and outline of the fox with a 2h or 4h pencil. Add the eyes and nose to make sure the placement is right.

STEP 2

I like to start with the eyes when drawing or painting animals or people, and then work from there. Add a light wash of orange mixed with burnt sienna for the base color of the fur, being careful not to paint into the lighter areas.

TAKE YOUR TIME WITH THE INITIAL SKETCH. WHEN YOU'RE WORKING AT SUCH A SMALL SCALE, BEING OFF WITH THINGS LIKE FACIAL FEATURE PLACEMENT BY JUST A FRACTION COULD CHANGE THE ENTIRE PAINTING.

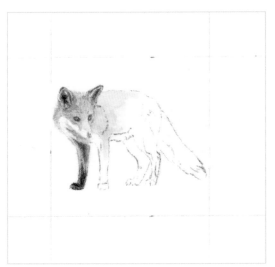

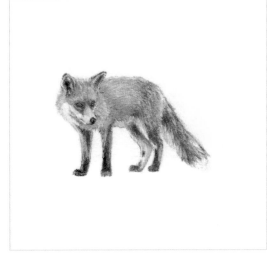

STEP 3

Add burnt umber for the ears and paws, and then gradually build up the layers with some darker shadows, following the growth pattern of the fur with brushstrokes. This gives the impression of individual hairs, especially when brushing darker paint into lighter paint.

STEP 4

Continue working down the body in layers of washes, going from light to dark and then adding brushstrokes for fur texture. The lighter the touch of the brush, the thinner the line you can achieve.

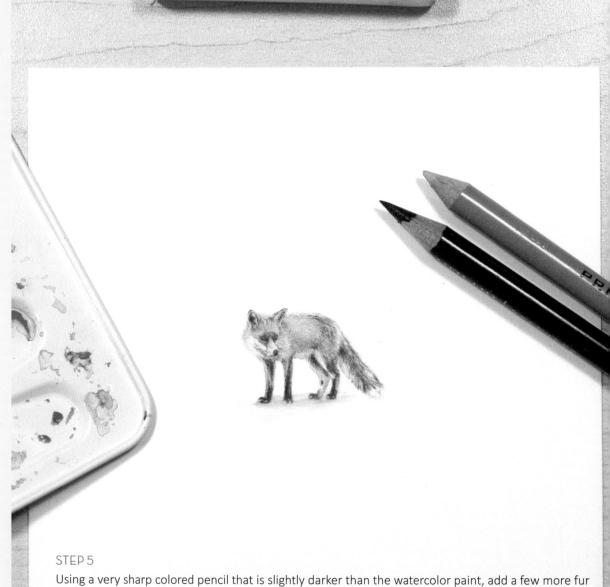

STEP 5

Using a very sharp colored pencil that is slightly darker than the watercolor paint, add a few more fur lines, adding two or three strokes at a time before sharpening.

TO GET A VERY SHARP POINT ON YOUR COLORED PENCIL,
USE A SCRAP OF 150-GRIT SANDPAPER.

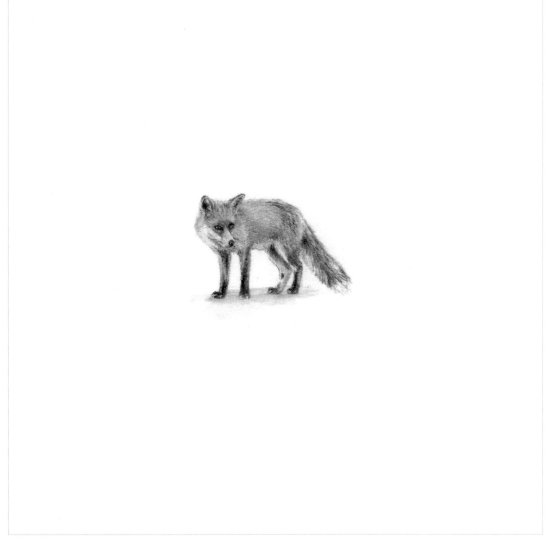

STEP 6

To finish, add a few more fur highlights, as well highlights on the eyes and nose, with white opaque gouache. Add a light wash of Payne's gray for the shadow underneath the fox. Once all the paint is dry erase the pencil lines.

BEAR

With short brushstrokes and a few well-placed highlights, you'll find it's relatively easy to develop fluffy fur texture for this big, brown bear—the key is to work in layers!

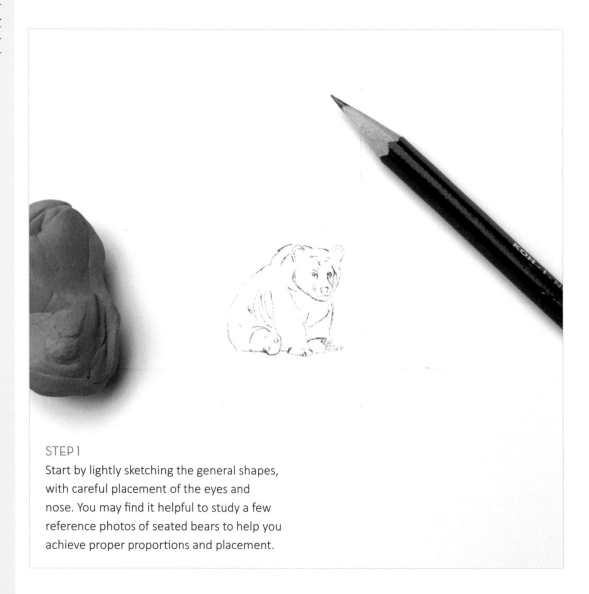

STEP 1

Start by lightly sketching the general shapes, with careful placement of the eyes and nose. You may find it helpful to study a few reference photos of seated bears to help you achieve proper proportions and placement.

USING AN INTENSE COLOR LIKE ORANGE IN THE
EYES WILL HELP THIS SMALL AREA OF THE FACE "SHOW UP"
ON THE PAGE.

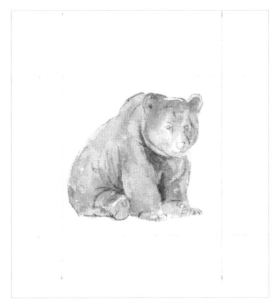

STEP 2
Add a light wash of dark and light
values using a mixture of burnt
sienna and burnt umber.

STEP 3
Create a hint of detail in the eyes with
a touch of orange. Use black to add
depth to the nose and eye sockets.

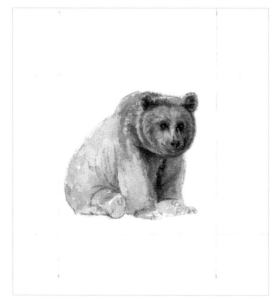

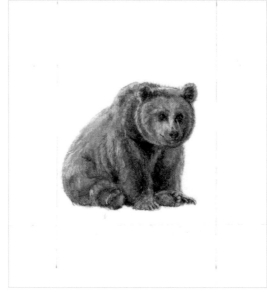

STEP 4

Develop texture in the fur by adding more layers of burnt umber and burnt sienna, with a touch of purple in areas of shadow.

STEP 5

Continue adding layers of burnt sienna and burnt umber, using short brush-strokes to create the illusion of fur. Be sure to brush on the paint in the direction of fur growth.

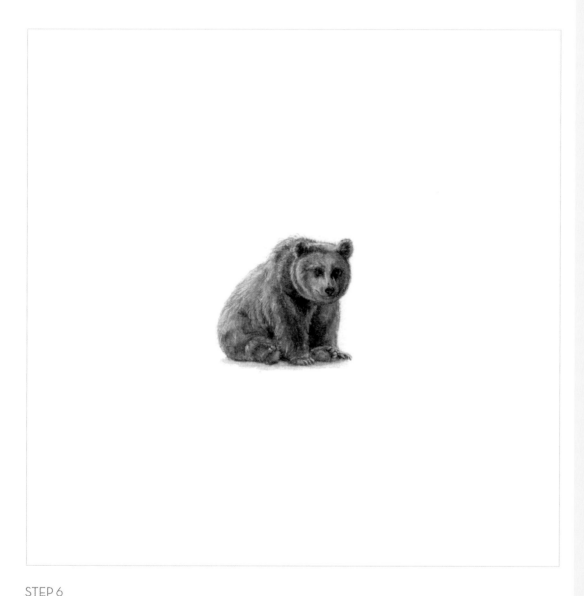

STEP 6

Add white highlights in the fur and eyes, as well as on the sharp claws.
Finish by using Payne's gray to paint the bear's shadow. When the paint
is dry, erase the pencil marks.

CHICK

What could be sweeter than a fluffy golden chick? Keep the outline of the chick's body loose, and build the shape with fluffy texture to create the downy appearance.

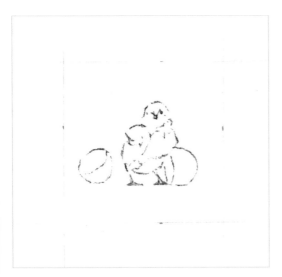

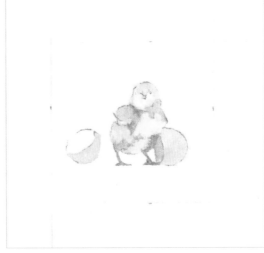

STEP 1
Start with a rough outline of the basic shapes of the chick and egg.

STEP 2
Apply a light wash of yellow ochre in areas of shadow and a light yellow wash in highlighted areas. Mix yellow ochre and raw umber for the eggshell.

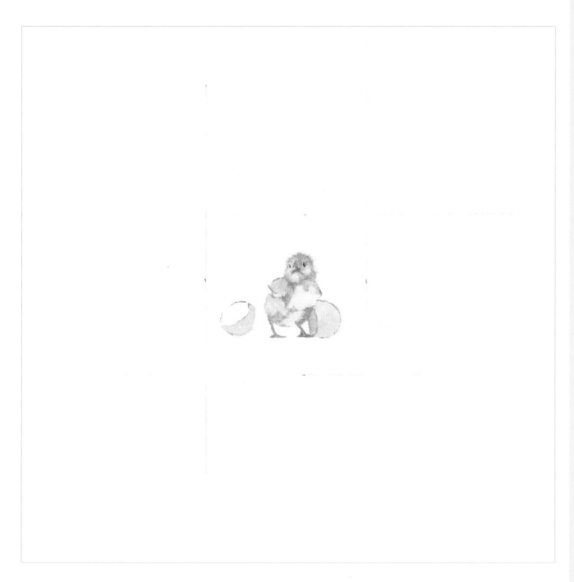

STEP 3

Add another light wash of yellow, with a touch of ultramarine blue in the shadow areas to create depth. On the highlighted side, add a touch of red to reflect warmth from the light source. Add detail to the eyes and beak.

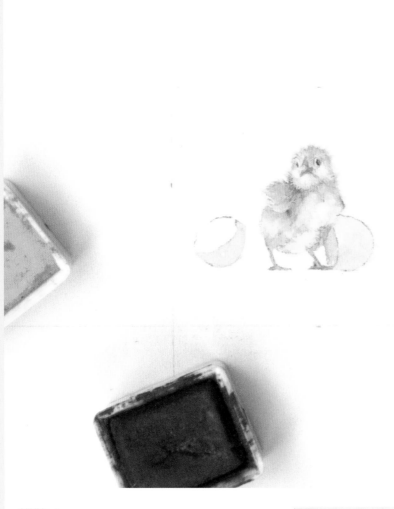

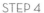

STEP 4

Continue to build with layers of terra cotta and ultramarine blue mixed with yellow ochre for depth. Use warmer tones on the highlighted side and cooler tones on the shadow side. Use short brushstrokes to create the illusion of feathery down.

STEP 5

Add detail to the eggshell using a mix of raw ochre and ultramarine blue. Add highlights on the edges of the eggshell and feathers with white gouache to add dimension.

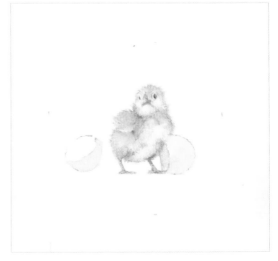

STEP 6

Apply another wash to the eggshells. Finish with
a shadow of Payne's gray beneath the chick and
eggshell halves. Don't forget to add shadow
on the tops of the eggshell pieces, cast by the
chick's body.

LAMB

At first glance this sweet lamb may seem to be simply black and white. But take a closer look, and you'll discover a range of colors hidden beneath. In nature, white is rarely pure white, and black rarely pure black. Mix your colors to create true and natural neutral shades.

STEP 1

Lightly sketch the general outline of the shapes, paying close attention to the placement of the eyes and nose.

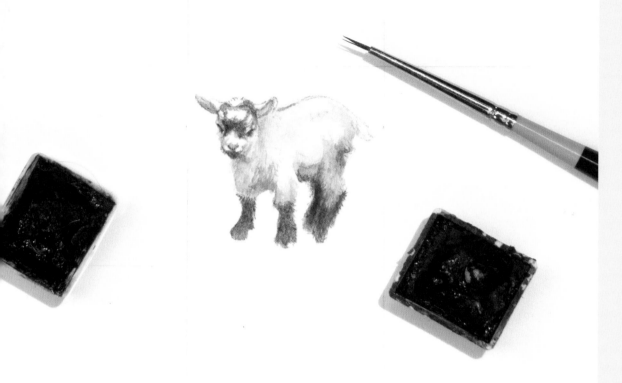

STEP 2

Add a light wash of black to the face and legs. Use Payne's gray for the shadow areas of fur, but keep the application very light in this early painting stage.

STEP 3

Add detail in the face with more layers of black and Payne's gray, using short brushstrokes to create the illusion of fur. Use a light wash of alizarin crimson inside the ears. Add details to the eyes, nose, and chin, using a touch of yellow ochre and purple in the areas of shadow.

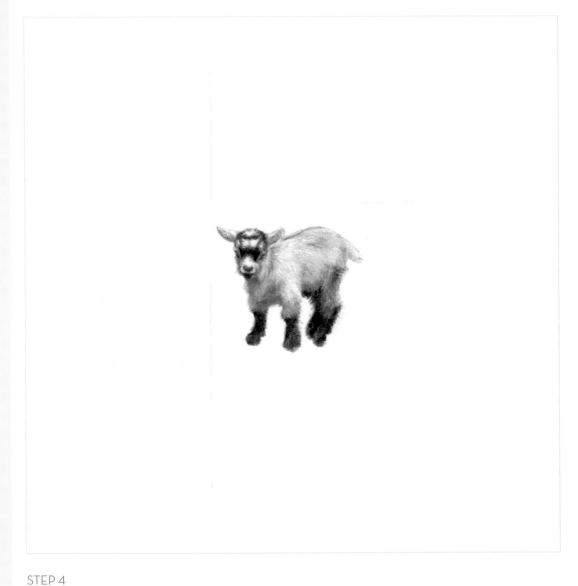

STEP 4

Apply another layer of color to further define
the darkened shadows in the wool. Then use
short strokes of white gouache on top for detail.

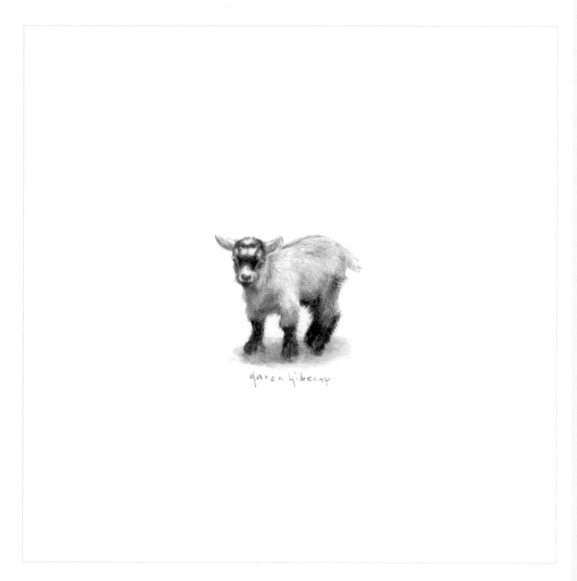

STEP 5

Finish by adding a shadow with Payne's gray.

DACHSHUND

When painting or drawing a dark subject like this adorable dachshund, be careful not to start too dark in the early stages of the process. It's always easier to build and add color than it is to take away.

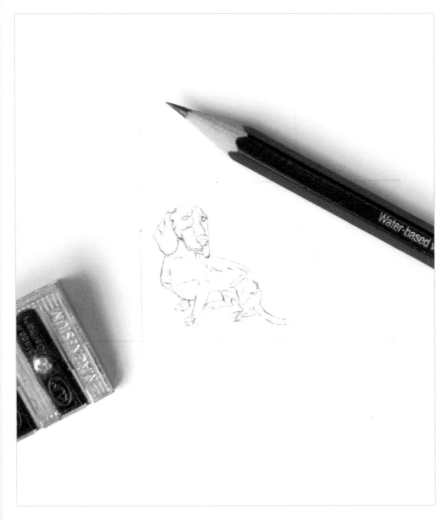

STEP 1

Start with a light sketch of the general shapes, paying close atten-tion to placement of the eyes and nose. Include the fur markings in your initial sketch.

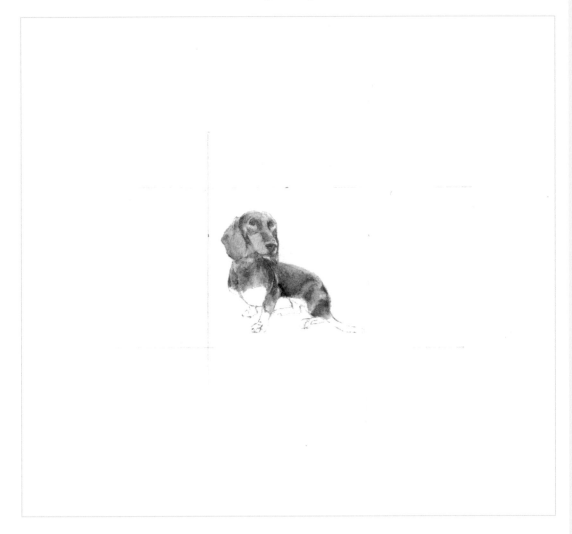

STEP 2
Apply a light wash of Payne's gray and
raw sienna. Don't add too much color
at this point.

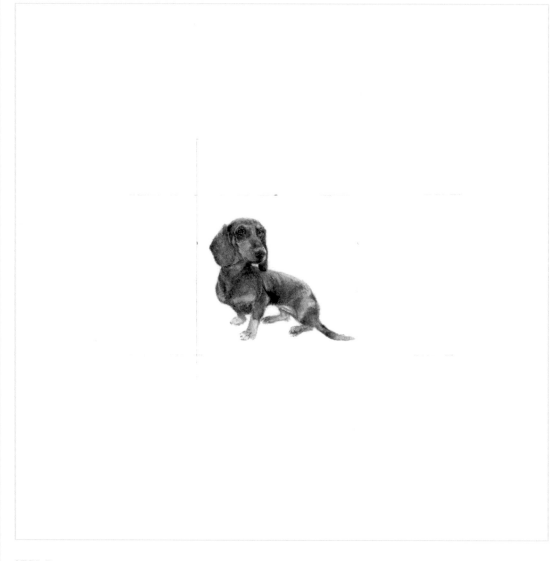

STEP 3

Add detail in the eyes, using orange for color and black to add depth to the eye sockets. Use a light wash of ultramarine blue for highlights in the fur. Then add more detail in the shadowed fur, using black and burnt sienna, plus orange for more intense shadow areas.

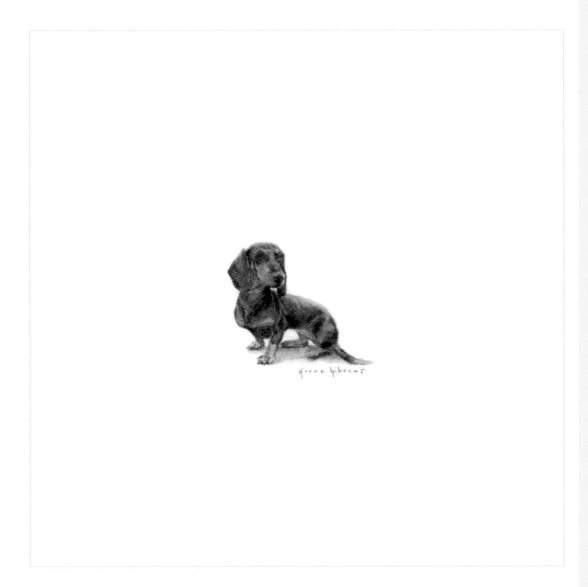

STEP 4

Add more layers of black and burnt sienna to create depth. Then add highlights of phthalo blue and white on the side facing the light source, and highlights of ultramarine blue and white on the shadow side. Finish with a shadow of Payne's gray.

GALLERY

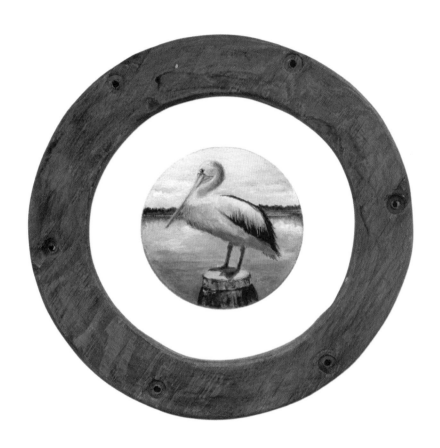

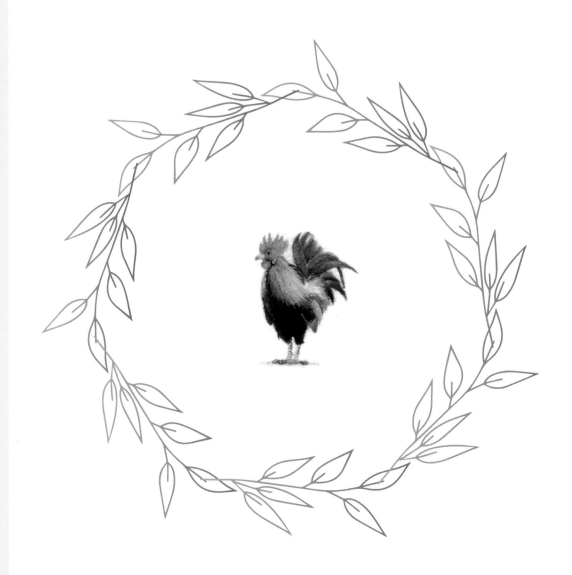

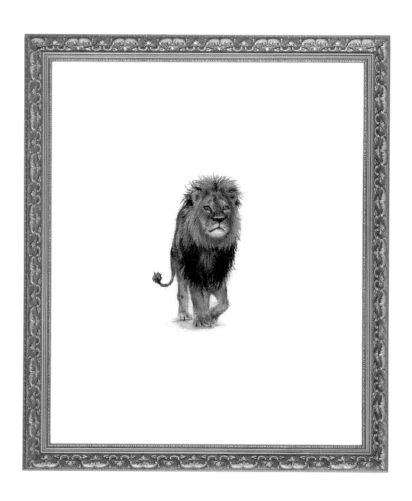

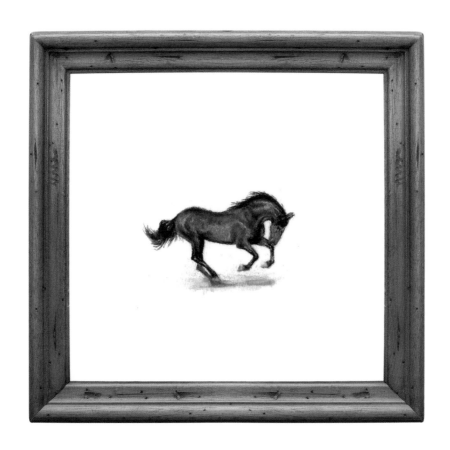

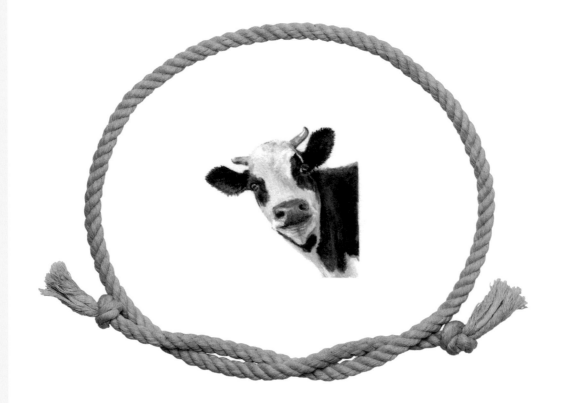

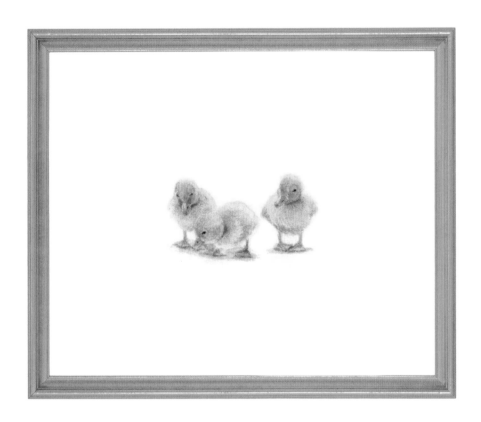

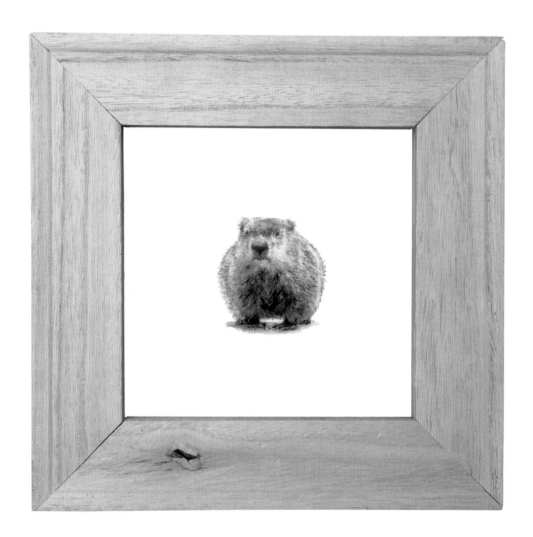

DOGS

Basset Hound

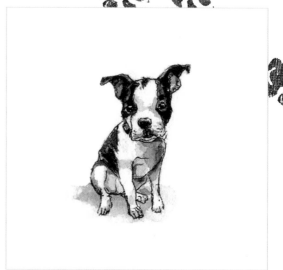

Boston Terrier

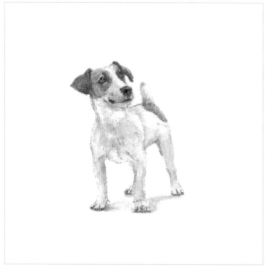

Jack Russell Terrier

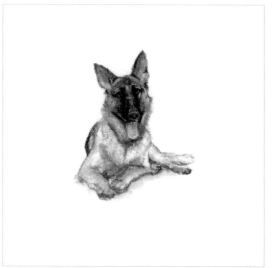

German Shepherd

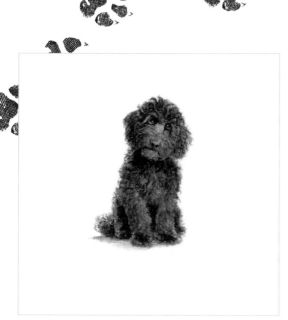

Labradoodle

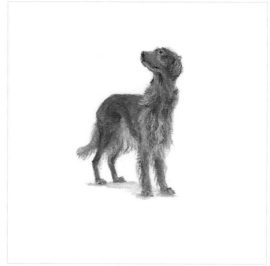

Irish Setter

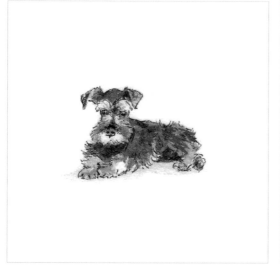

Schnauzer

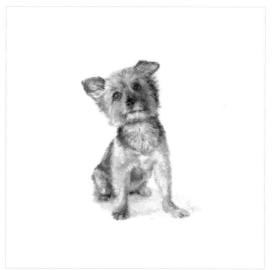

Yorkshire Terrier

TINY ANIMALS SKETCHBOOK

Use these squares and practice areas to draw the step-by-step projects in this section or your own favorite animals!

TINY FOOD & DRINK

TACO

When rendering highly textured food like this taco, don't try to add too much detail. A few well-placed strokes and simple techniques will create the illusion of texture and lets the eye imagine the rest.

STEP 1
Using a 2H or 4H pencil, sketch the general shapes and outline of the taco and filling.

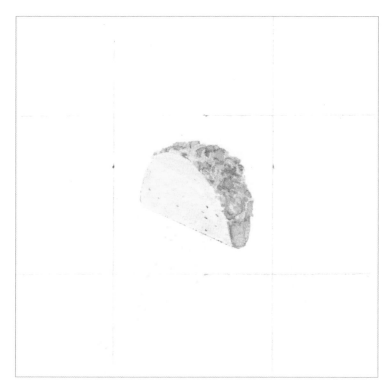

STEP 2

Add a light wash of yellow ochre for the shell, carmine red for the tomatoes, lime green for the lettuce, light yellow for the cheese, and burnt sienna for the beef. At this point don't focus too much on detail, but rather laying in a base of color.

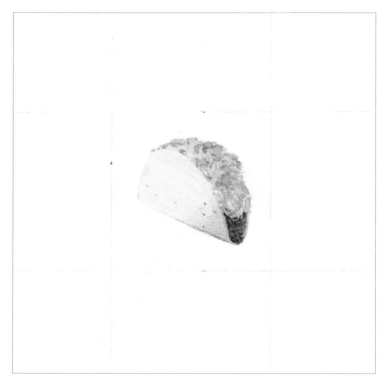

STEP 3

Begin building up washes of color in the darker areas of the ground beef, working from light to dark and painting wet-into-wet. Add another layer of yellow on the taco shell and begin to refine the edges.

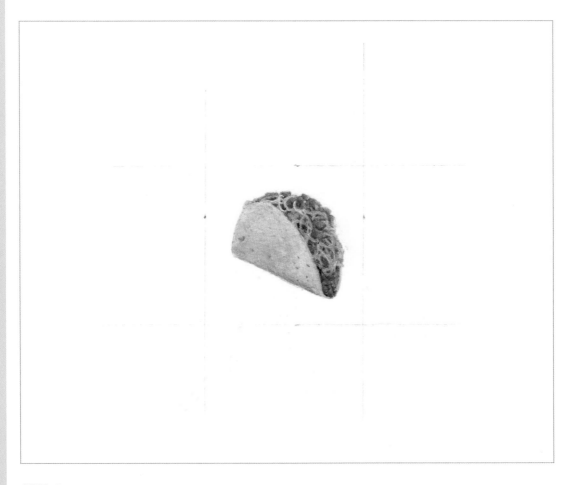

STEP 4

Add more color to the toppings. Then use Payne's gray to paint the shadowed areas in the tomatoes and lettuce. Use orange with just a touch of burnt sienna for the shadows in the cheese.

I WAS ABLE TO ACHIEVE THE VIBRANT COLORS I DESIRED WITH WATERCOLOR ALONE. IF YOU WANT TO DEVELOP EVEN MORE DEPTH IN YOUR PIECE, FEEL FREE TO ADD COLORED PENCIL FOR VIBRANCY.

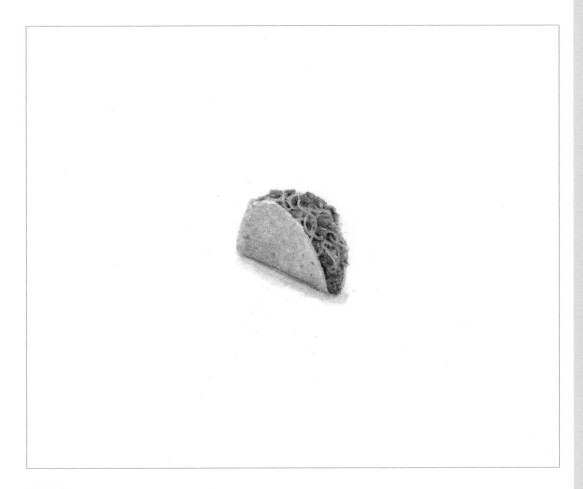

STEP 5

Use white opaque gouache to add highlights to the cheese, tomatoes, and beef, as well as the edge of the shell. With a light wash of Payne's gray, paint the shadow under the shell and the seeds on the shell. After adding one more pass of my darker paint colors for depth, let the paint dry before erasing the pencil lines.

MARTINI & SHAKER

Painting this martini glass and cocktail shaker is a great study in monochromatic color schemes. You only need a few paint colors and steps to render this classy cocktail.

STEP 1

Start by lightly sketching the general outline and larger shapes with a 2h or 4h pencil.

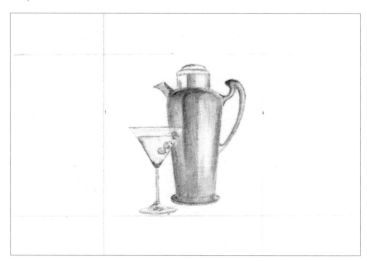

STEP 2

To add color, build with light washes, paying attention to the color shift of warm to cool on the shaker. As you refine the edges, be careful to leave the reflective highlights alone.

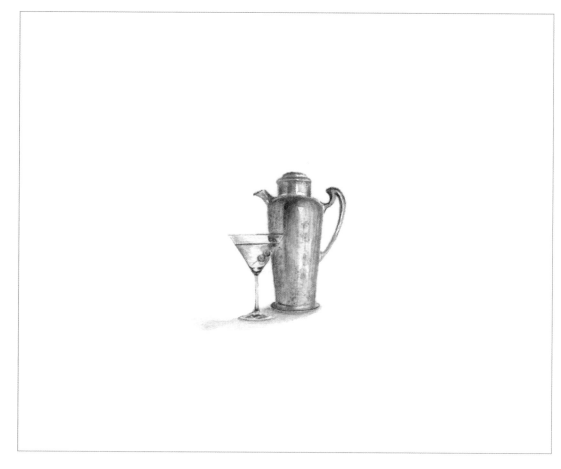

STEP 3
Paint the olives before adding highlights on the rim of the glass and reflections on the shaker with white gouache. Use a light wash of Payne's gray for the shadow underneath and just a hint of black in the darkest reflections.

MUSHROOMS

Even the simplest of subject matter can be an interesting choice for tiny artwork!

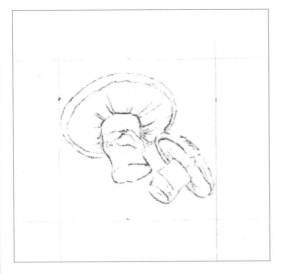

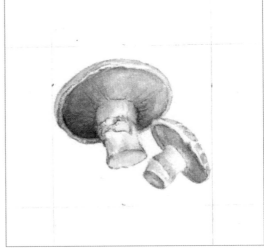

STEP 1
Using a 2h or 4h pencil, lightly sketch the general shapes and outline of the mushrooms.

STEP 2
For the first layer of paint use a light wash of carmine red and orange on the underside of the caps and bottoms, keeping the tones cooler. Warm up the tops and stems with a wash of yellow ochre.

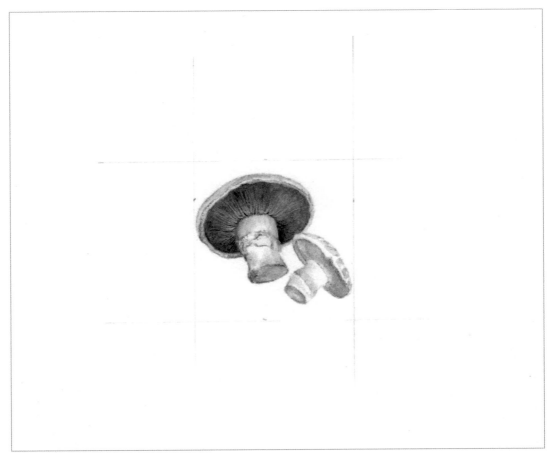

STEP 3

Continue layering washes of color on the larger mushroom with carmine red and orange, adding in ultramarine to darken the underside of the cap, and painting in the same direction as the lines of the gills. Start adding detail to the stem and cap with ultramarine and burnt umber.

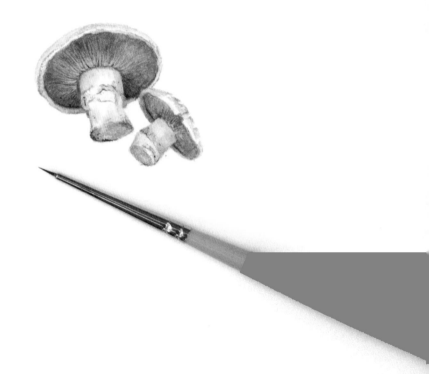

STEP 4

Repeat the layering process on the smaller
mushroom, slowly building up the darker
areas. Then add final details of dirt and spots
on the mushrooms.

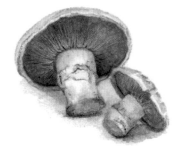

STEP 5

Using opaque white gouache mixed with a tiny bit of cobalt, add highlights to the edges of the caps and the gills underneath the caps. Use a light wash of Payne's gray to paint the shadow under both mushrooms. Once the paint is dry, erase the pencil lines.

CUPCAKE

This teeny-tiny cupcake looks good enough to eat—and it's a cinch to paint your own. Just follow the step-by-step instructions. You can make the cake and frosting any "flavor" you wish!

STEP 1

Lightly sketch the outline of general shapes and shadows.

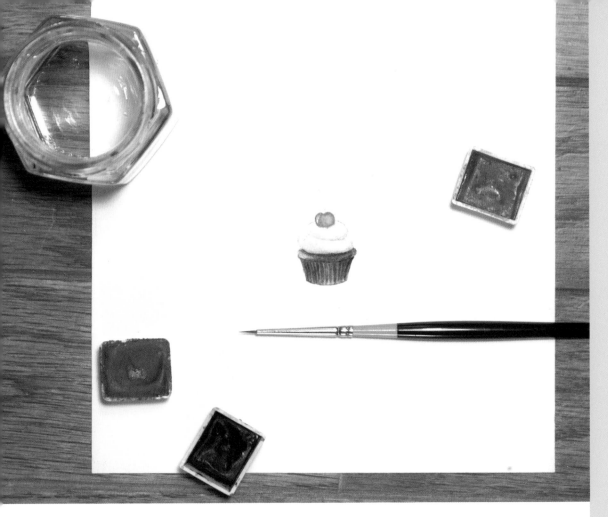

STEP 2

The light source here is cooler, which creates warmer shadows and cooler highlights. The cupcake liner is mainly in shadow, so use washes of warm browns, such as burnt sienna. The cupcake reflects the light source on the left side, so use cooler browns, such as burnt umber mixed with phthalo blue. Apply a very light wash of color for the frosting and a wash of red on the cherry, leaving the highlight unpainted.

STEP 3

Add more detail and darker layers to the cherry, along with a mix of lime green and burnt sienna for the stem.

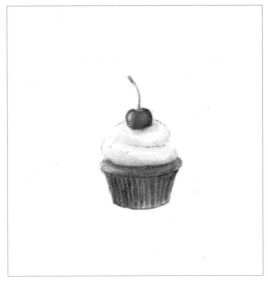

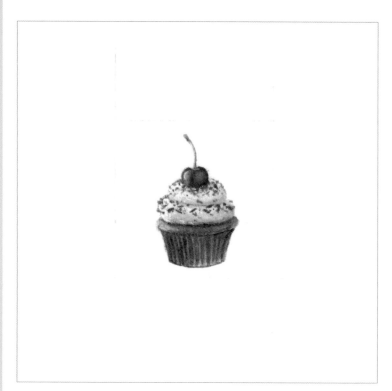

STEP 4

Working down the cupcake, add more shadows to the frosting before painting in chocolate sprinkles.

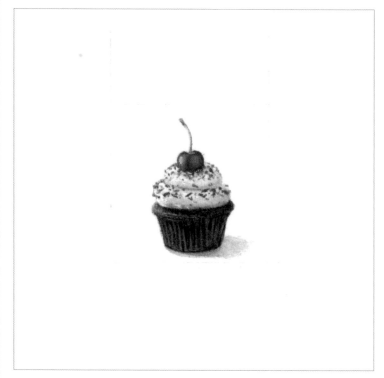

STEP 5

On the left side of the cake, add highlights of purple and phthalo blue mixed with white gouache to create the cooler tones; on the darker right side, use a mix of burnt sienna and black. Paint the ridges in the liner using burnt umber and burnt sienna.

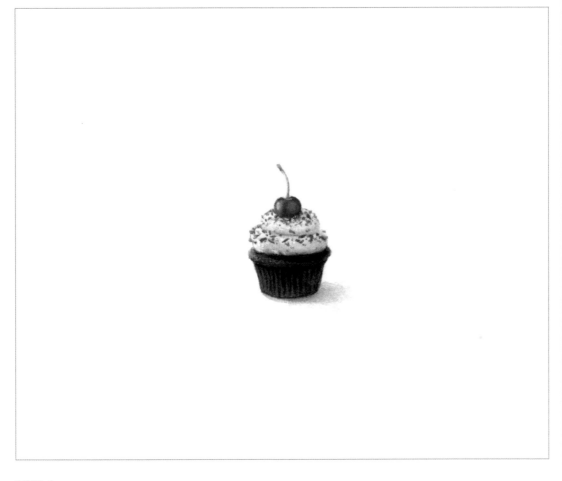

STEP 6

Add final highlights with white gouache and a
shadow of Payne's gray underneath the cupcake
to complete the painting.

COFFEE & DOUGHNUTS

Coffee and a doughnut (or two) are the perfect pairing! There are a lot of fun textures to render in this delicious combo—from the smooth porcelain cup to the delicate frosting on the doughnuts.

STEP 1

Measure a 1¼" x 1¼" square, and lightly sketch the general shapes and outlines of the cup and doughnuts.

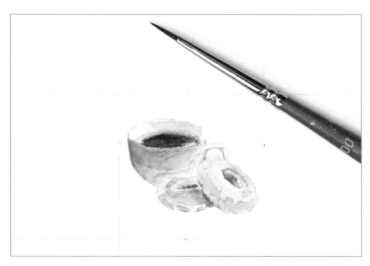

STEP 2

Add a light wash of ultramarine blue with a hint of phthalo blue on the left side of the cup, transitioning to a cooler and lighter blue consisting of ultramarine with a hint of purple on the right side. Apply a wash of yellow ochre on the doughnuts, with a mix of yellow ochre and alizarin crimson for the cooler shades. Add burnt umber for the shadow areas.

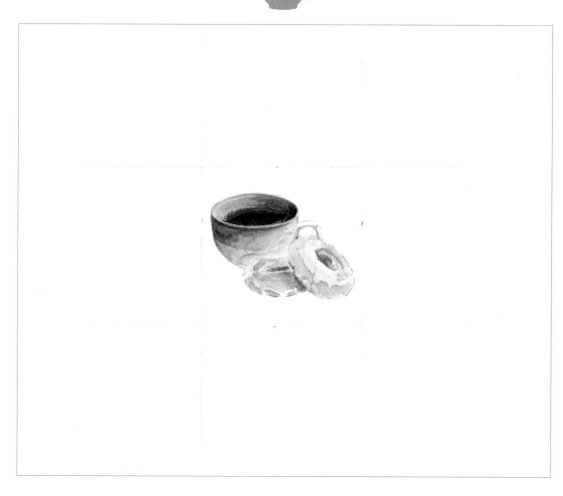

STEP 3

Continue working on the cup, adding another wash of ultramarine blue with Payne's gray for the darker left side. Paint the coffee with raw umber in the darker areas and burnt sienna in the lighter areas. Mix yellow ochre with white gouache to paint the bubbles, and mix ultramarine blue with just a touch of white gouache (for opaqueness) to paint the highlight.

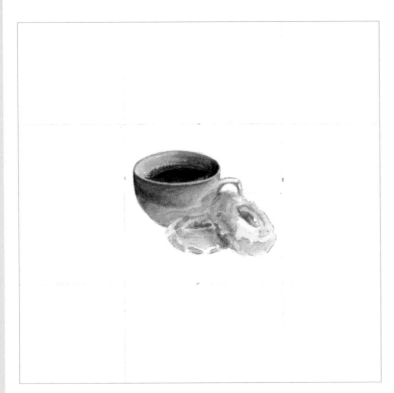

STEP 4

Add another pass of darker blue on the left side of the cup, and a hint of yellow ochre for the reflection of the doughnuts on the cup. Build up warmer layers of orange color on the doughnuts.

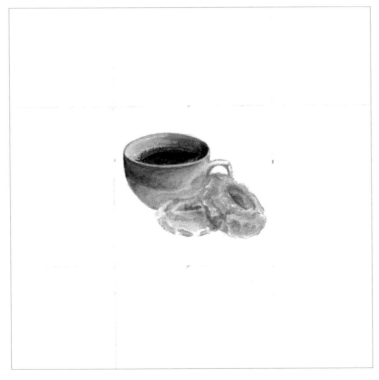

STEP 5

Add more layers of color on the glaze using phthalo blue, and add highlights with white gouache.

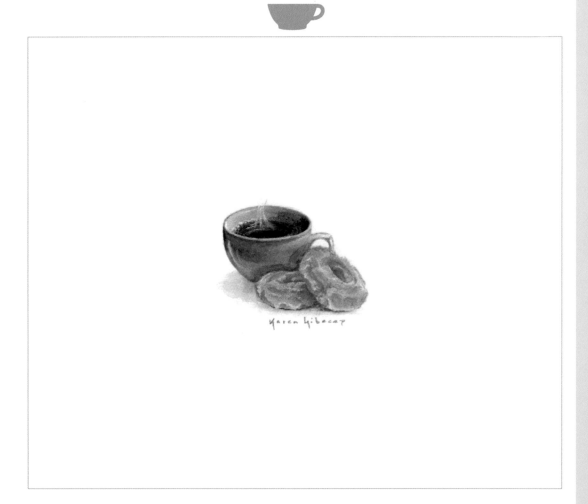

STEP 6

Add highlights to the coffee cup, as well as a bit more yellow ochre to finesse the doughnuts' reflection. Finish with a shadow under the cup and doughnuts, using Payne's gray.

GALLERY

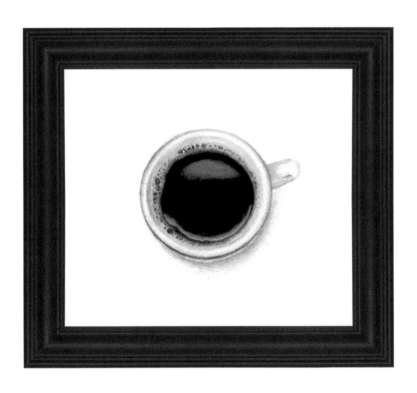

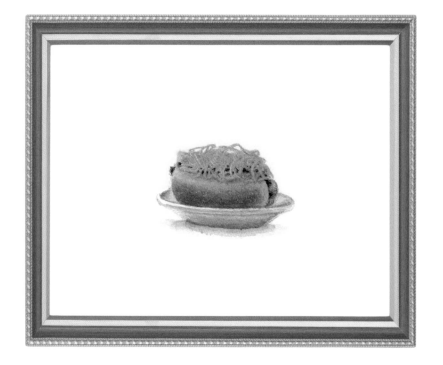

HAPPY HOUR

Beer

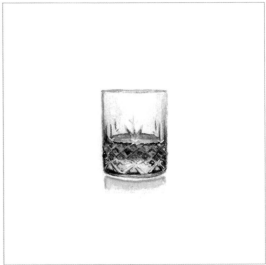

Bourbon Neat

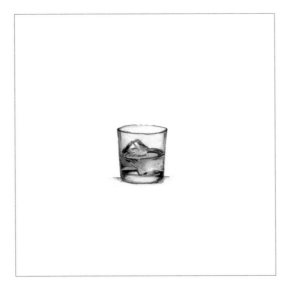

Bourbon on the Rocks

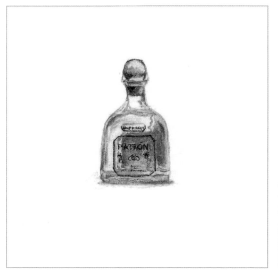

Tequila

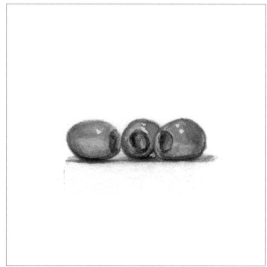

Olives

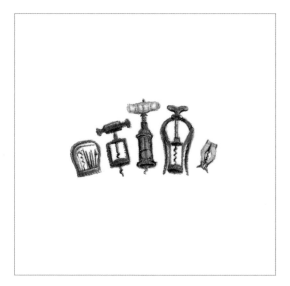

Corkscrews

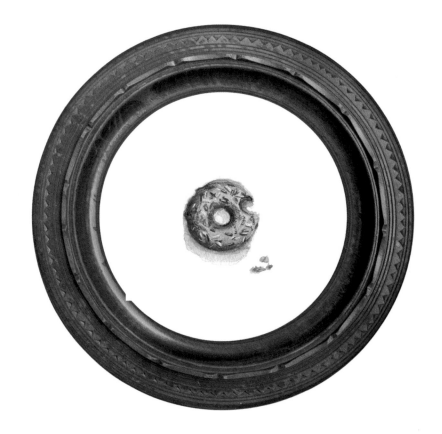

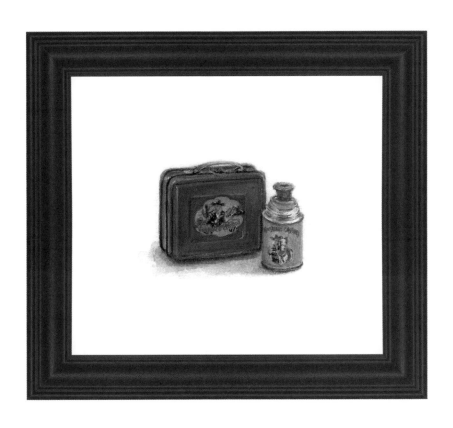

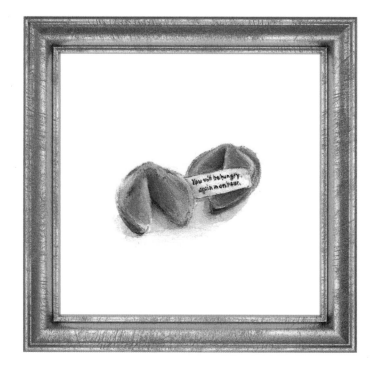

TINY FOOD & DRINK SKETCHBOOK

Use these squares and practice areas to draw tiny versions of your own favorite things to eat and drink!

TINY THINGS
& PEOPLE

VASE OF FLOWERS

What's sweeter than a miniature vase of pretty blooms? My bouquet features ranunculus, but you can draw or paint any flower you like!

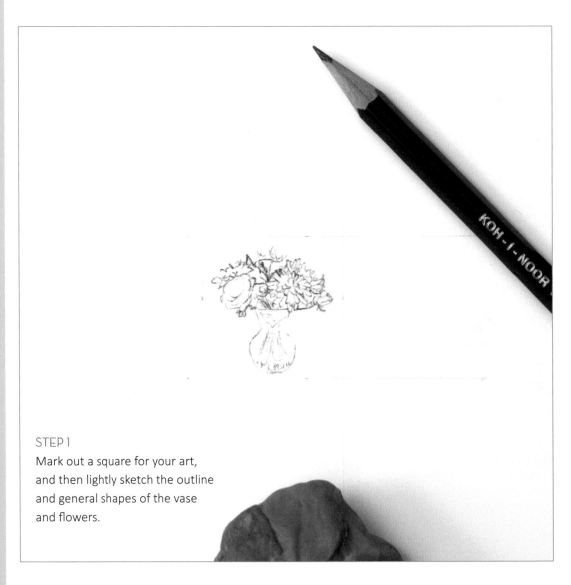

STEP 1

Mark out a square for your art, and then lightly sketch the outline and general shapes of the vase and flowers.

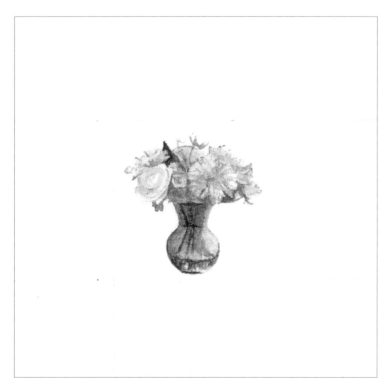

STEP 2

Block in general color with light washes. Don't worry about details at this stage.

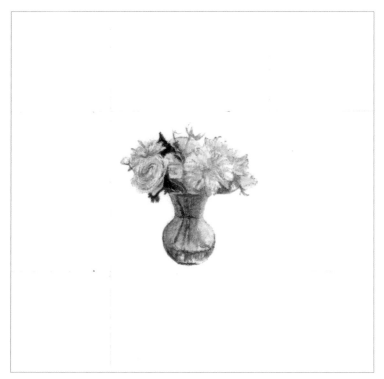

STEP 3

Once you have laid in the basic colors, you can start adding detail and depth by adding darker values in the flowers and leaves. I also added some white on the tips of the petals.

THE KEY TO RENDERING REALISTIC CLEAR GLASS
IS TO ADD PLENTY OF WHITE HIGHLIGHTS TO HELP SHAPE
THE VESSEL.

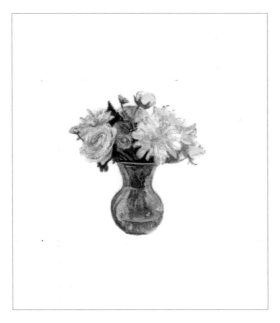

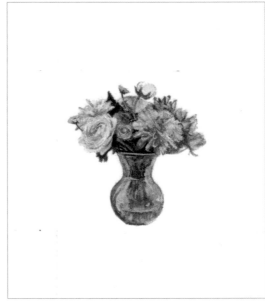

STEP 4

Continue adding the darker values and details in the flowers and leaves, as well as the vase.

STEP 5

Finish the flowers with some lighter highlights and a hint of color on the tips of the petals. Use white gouache for the highlights.

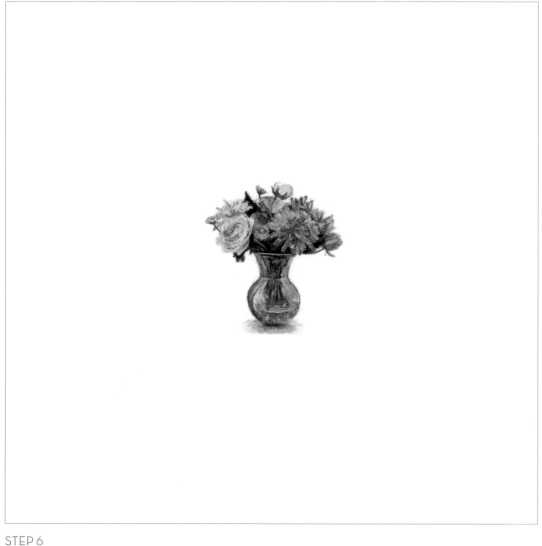

STEP 6

To finalize the illustration, add a shadow under the vase with Payne's gray. Add a few more highlights to the glass vase, and erase the pencil guides.

ICONIC CAR

This step-by-step demonstration of a stylish, iconic car is shown from a three-quarter perspective. This is a great approach for showing the depth and shape of your subject. Note that as the car turns further away from the point of view, the details diminish in size.

STEP 1

Mark the square for the art, and then lightly sketch the general shapes and outline of the car.

STEP 2

Start with a very light wash of phthalo blue, with
a touch of yellow ochre for the side panels. Leave
the white of the paper for highlights.

STEP 3

Use a light wash of phthalo blue on the hood
of the car as well. Add ultramarine blue to the
phthalo blue and yellow ochre mixture to paint
the darker values.

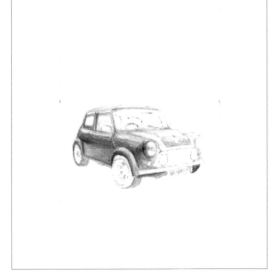

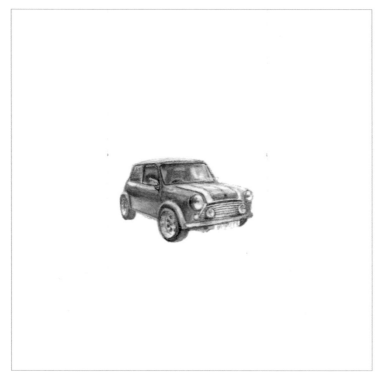

STEP 4

Begin putting in detail on the wheels and interior with black and Payne's gray, with a touch of yellow ochre in the reflections. Again, be careful to leave the lighter areas—it's much easier to make the painting darker than to lighten it.

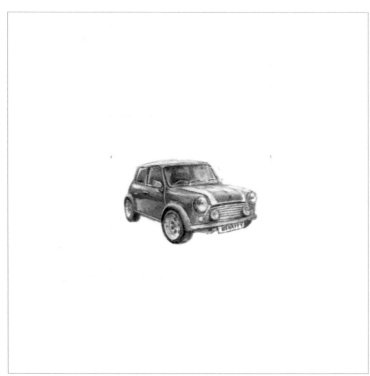

STEP 5

Apply one more layer of color to darken the darker reflections and details in the wheels and grill on the front of the car. Add the brighter highlights with white gouache.

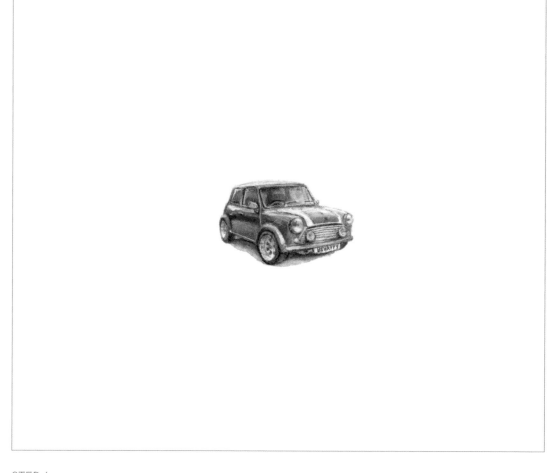

STEP 6

Use just a hint of yellow ochre in the headlights
and interior, and add shadow under the car with
Payne's gray. Erase the pencil lines to complete
the painting.

BALLERINA

This tiny drawing is rendered using graphite pencils across a range of hardness. I always start with the harder (lighter) pencil first and gradually work my way to the softer (darker) pencils for depth.

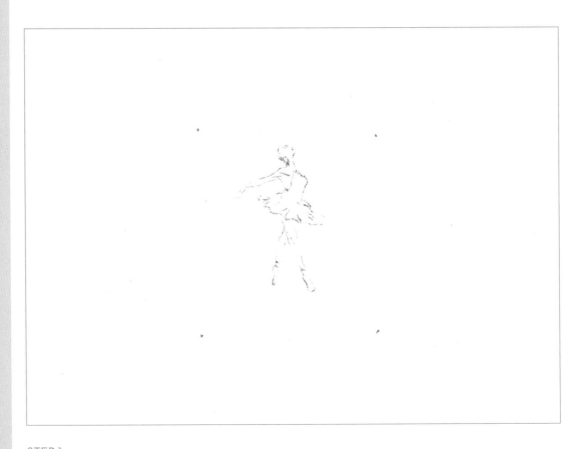

STEP 1

Start by lightly sketching a rough outline of the basic shapes using a hard pencil, such as 2H.

THE SOFTER THE PENCIL LEAD, THE MORE CHALLENGING IT IS TO MAINTAIN A FINE POINT. WHEN YOU'RE WORKING ON A MINIATURE SCALE, USE 4H OR 6H PENCILS FOR TINY DETAILS.

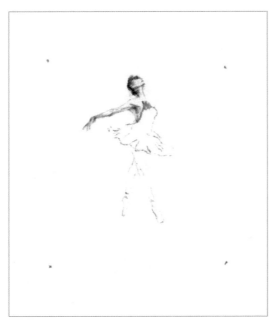

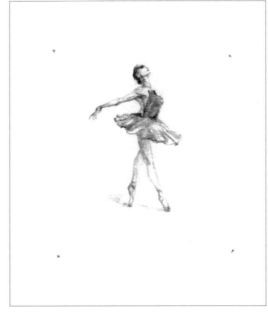

STEP 2
Use a 4H or 6H pencil to add shadows under the hand and arm, jawline, and hair. I recommend keeping a really good pencil sharpener close at hand to keep a fine point on the pencil. Use a piece of sandpaper to sand the edge of the pencil to create an even finer, smoother point for the tiny details.

STEP 3
Continue adding shadow to the rest of the figure with the harder lead pencils.

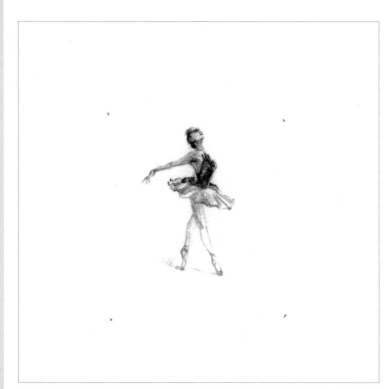

STEP 4

Go back over the darker shadow areas in the hair, eyes, and bodice of the tutu with a 2B or 4B (softer) pencil.

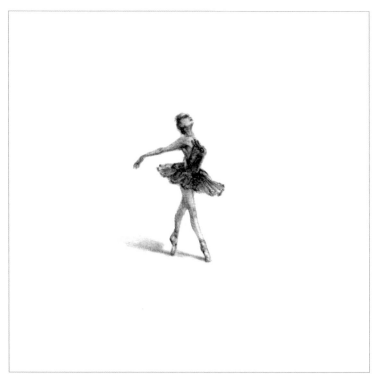

STEP 5

Continue working with a 2B pencil to create the folds in the skirt and the shadows on the soles of the shoes. If need be, you can go back over these areas with a harder lead (2H or H) to help blend the darker areas.

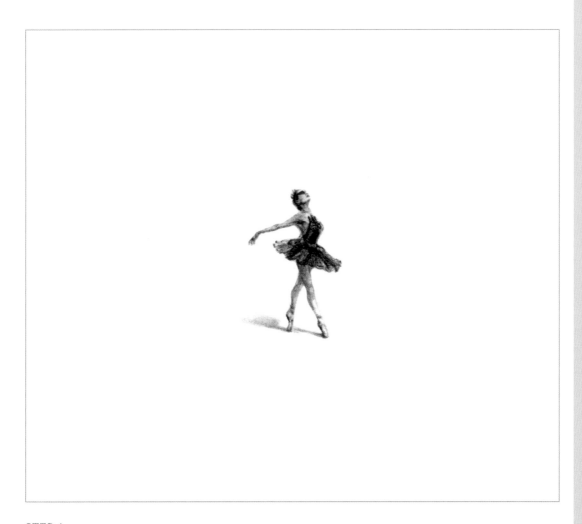

STEP 6

Make one more pass with a softer, darker pencil in the shadow areas of the tutu, armpit, and top part of the legs. Use a tortillon to smooth areas such as the legs and the ground shadow to complete the drawing.

INKWELL & QUILL

It's easy to create a beautiful colored glass texture like this pretty ink bottle. By using various shades of the same color you can create the illusion of depth and reflection.

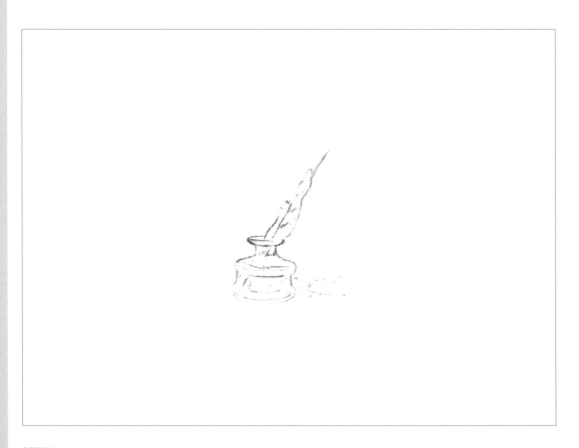

STEP 1
Lightly sketch the general shapes and outlines of the quill and ink bottle, as well as an ink splatter to the right of the bottle.

STEP 2

Apply a light wash of sap green for the darker areas of the glass inkwell, and use raw umber for the top ring.

STEP 3

Continue blocking in the darker shapes of the inkwell with sap green, and block in the lighter highlights with a light wash of sap green. Use pure black paint for the ink splatters. Mix black with a bit of white to create dark gray to paint the feather, using a very light touch to create the individual hairs.

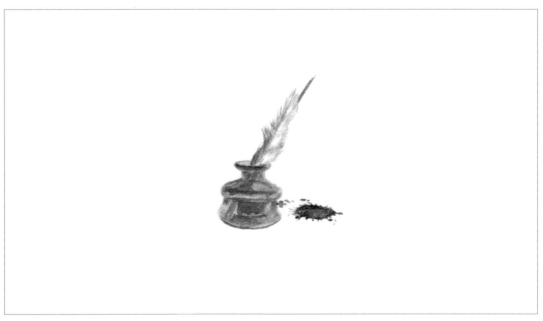

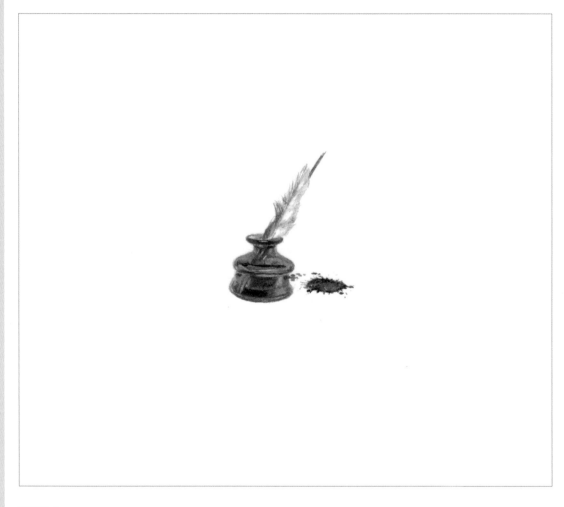

STEP 4

Add black in the darker areas on the inkwell, and
paint the highlights with a mix of phthalo blue
with a touch of white gouache for opaqueness.
Use a touch of pure white gouache for the shiny
highlights of the glass. Apply a hint of raw sienna
to add warmth in the feather.

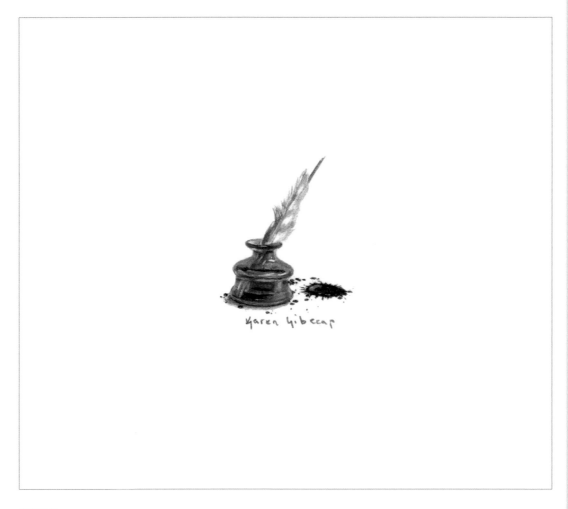

Karen Libecap

STEP 5

Make a final pass of black for the ink splat and
darker areas on the inkwell, with highlights
of phthalo blue to create depth. Finish with a
shadow of Payne's gray under the inkwell and
around the edges of the ink splat.

GALLERY

TRANSPORTATION

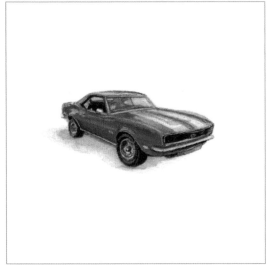

Vintage Sports Car

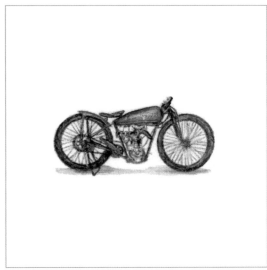

Vintage Motorcycle

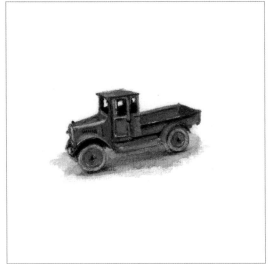

Vintage Truck

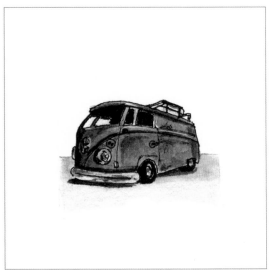

VW Bus

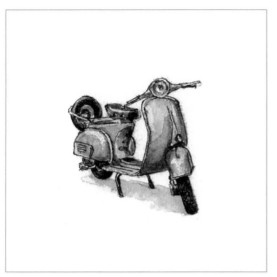

Scooter

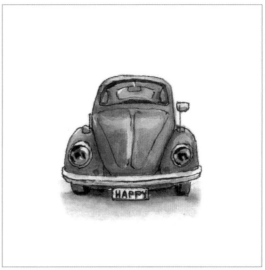

VW Beetle

SPORTS

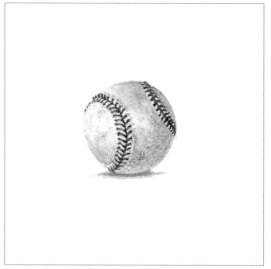

Baseball

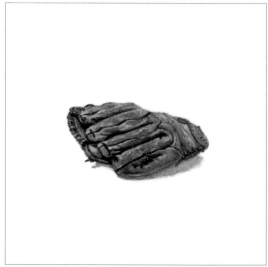

Baseball Glove

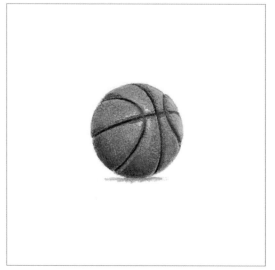

Basketball

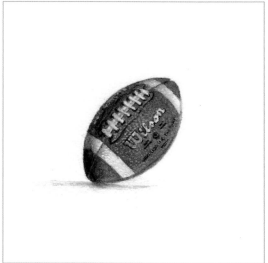

Football

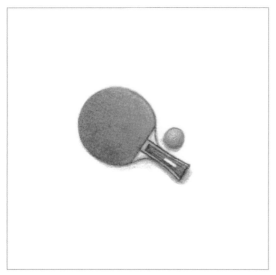

Ping-Pong

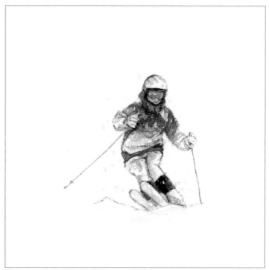

Skier

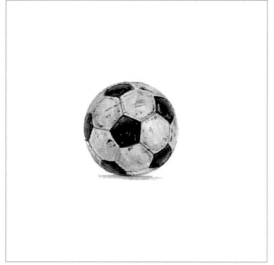

Soccer Ball

Tennis

TINY THINGS & PEOPLE SKETCHBOOK

Use these squares and practice areas to draw the step-by-step projects in this section or create a variety of other tiny things and portraits!

TINY PLACES

EAGLE NEBULA

The Eagle Nebula is a young, open cluster of stars in the constellation of Serpens and is home to several famous structures, including the Pillars of Creation. I find that space is one of the most interesting and beautiful places to draw or paint.

STEP 1

After measuring a 1¼" x 1¼" square, tape the outside edges. This keeps the edges crisp and the area around the painting free from smudges and paint.

STEP 2

Next lightly sketch the general shapes and outline of the image. I recommend using a 2H or 4H pencil for this step; both are very light and easily erasable when the painting is complete.

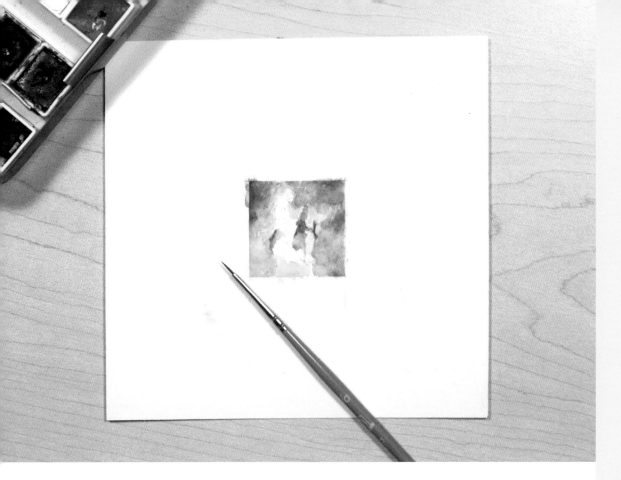

STEP 3

The first layer is a general color wash that will provide a foundation to build on. Don't worry about detail at this point. Be careful in the early stages not to make your painting too dark. It's much easier to add darks than it is to add lighter colors when working with watercolor.

STEP 4

Continue building up the color, laying paint wet-into-wet and really working the color into the paper. Begin defining the edges and adding some detail. For the background use yellow ochre, blending in some phthalo blue, then cobalt, and end with some purple in the darkest areas of the sky.

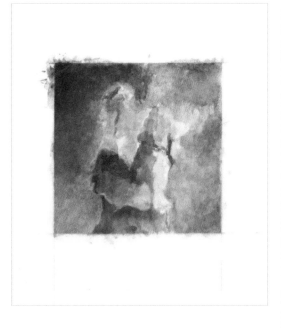

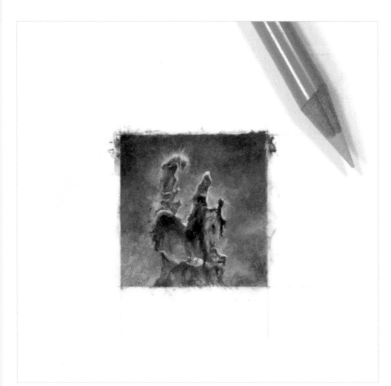

STEP 5

Sometimes I find it difficult to achieve the level of intensity I want with watercolors, so I add colored pencil. Try to match the color as closely as possible, and lay colored pencil on top of the areas that need it. To achieve a smooth finish, you can lightly brush mineral spirits on top of the colored pencil. This will help blend and diminish some of the strokes.

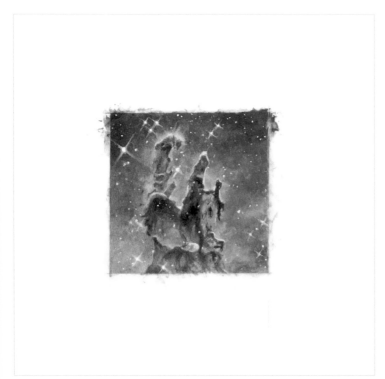

STEP 6

Make one more pass over the darker areas to add depth. To finish, use opaque white gouache to add stars and highlights along the edges of the formation. Because the gouache is water soluble, you can go back over the stars with a damp brush to soften the edges so they appear to be glowing.

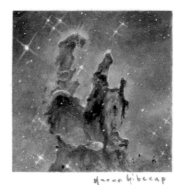

STEP 7

Once the painting is dry, remove
the tape, erase the pencil marks,
and sign your name if you like.

THE BEACH

Imagine your toes in the sand and the sun on your face as you paint this cheerful beach scene.

STEP 1

Tape all four sides of the painting to create a clean border. Then lightly sketch the general shapes.

STEP 2

Using a strip of tape under the horizon line, add a light wash of ultramarine blue at the top and gradually blend into phthalo blue toward the horizon. Leave the cloud shapes unpainted.

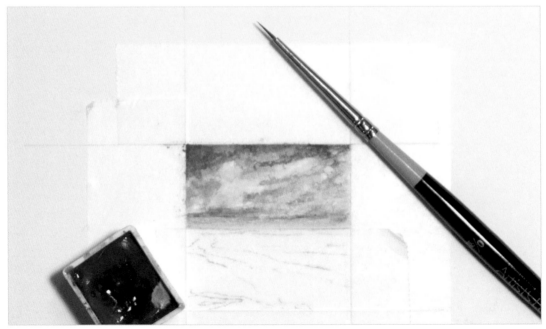

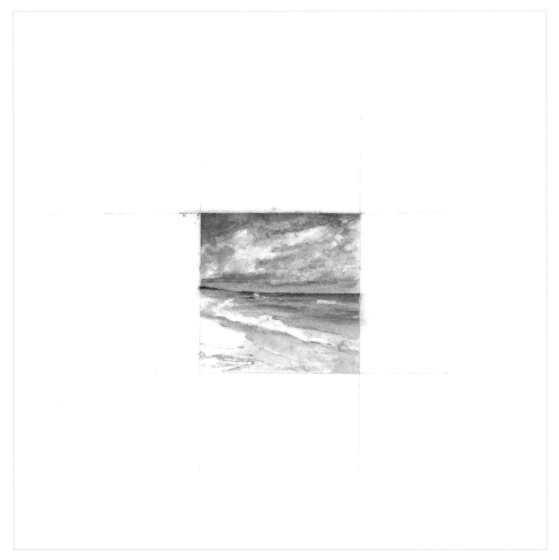

STEP 3

Once dry, gently remove the tape, and place a new piece of tape to protect the sky while you work on the rest of the scene. Mix phthalo blue and ultramarine blue to paint the water at the horizon line, and gradually blend into phthalo blue with a touch of yellow toward the bottom of painting. Use yellow ochre and sap green to create the distant sand bar and yellow ochre, purple, and alizarin crimson for the foreground sand.

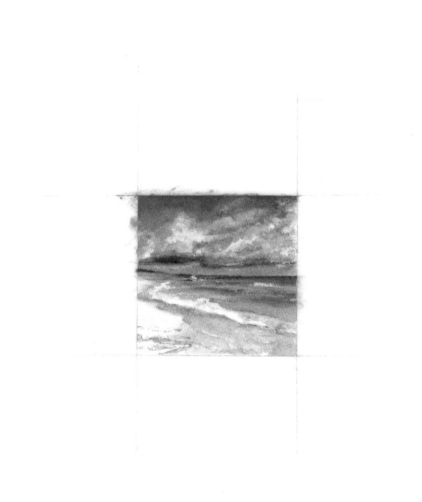

STEP 4

Remove the tape from the horizon line. Use purple and Payne's gray to add depth to the underside of the clouds. Use a tiny bit of yellow ochre at the tops of the clouds where they reflect warm sunlight. Add more layers of ultramarine blue and phthalo blue in the sky.

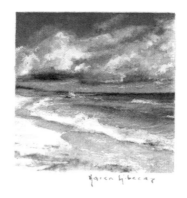

STEP 5

Add shadows and details to the waves. Then
apply a final layer of color in the sky and waves.
Use white gouache to add highlights to complete
the splashing waves. When the paint is dry,
remove the tape and erase the pencil lines.

UNDER THE SEA

For this vibrant under-the-sea scene I chose to start in one corner and work my way around, rather than work on the painting as a whole in stages.

STEP 1

Tape off all four sides of the painting to create clean edges. Lightly sketch the general shapes of the fish and coral.

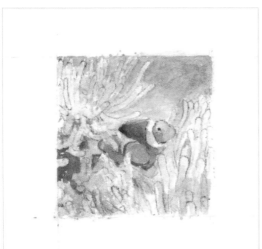

STEP 2

Add a light wash of general color to the entire painting—don't go too dark at this early stage. You can build color and depth as you go.

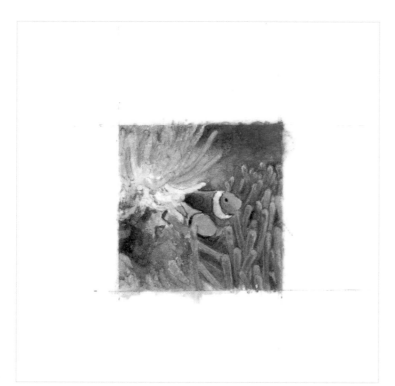

STEP 3

Mix ultramarine blue with a touch of phthalo blue for the vibrant background water. For the seaweed, use yellow ochre, phthalo blue, and sap green, and add white gouache for highlights.

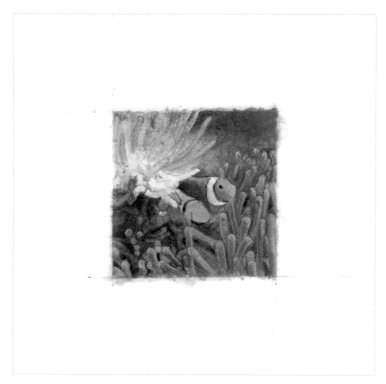

STEP 4

Continue working around the seaweed and adding detail to the clown fish with orange, red, and black.

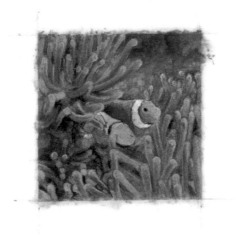

STEP 5

Paint the shadows of the fish with ultramarine
blue in the white areas and burnt umber in the
orange areas. Finish painting all of the seaweed
around the fish. Add any final white highlights to
strands of seaweed and one more layer of darks
to create depth.

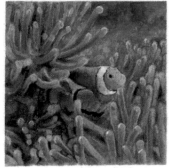

Karen Gilecap

STEP 6

Let the paint dry, and then remove the tape and
erase the pencil lines.

BIG BEN

Iconic landmarks are the perfect subject matter for miniature art, because you don't need to include a lot of detail to make them recognizable.

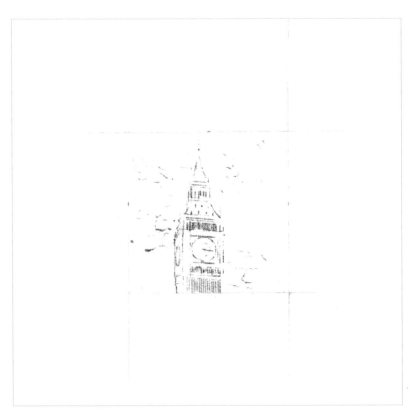

STEP 1
Measure a 1¼" x 1¼" square, and tape off the sides. Lightly sketch the general shapes and outline of the landmark.

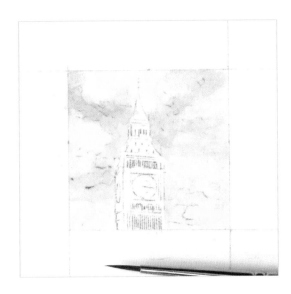

STEP 2

Start with a light gradated of wash of phthalo blue for the sky, making the paint lighter toward the bottom and adding a touch of yellow. Leave the white of the paper for the clouds. Add a very light wash of purple and Payne's gray to give depth to the clouds.

STEP 3

Add another layer of wash to the sky and, starting at the top of the building, begin to fill in with general color.

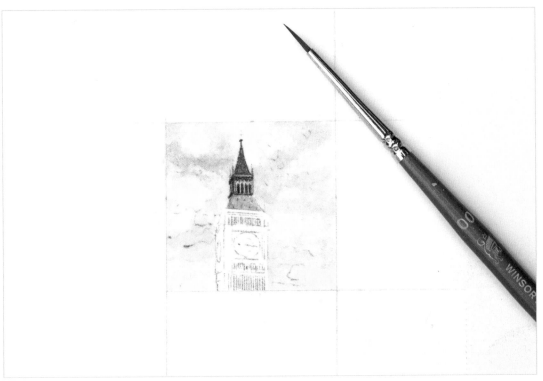

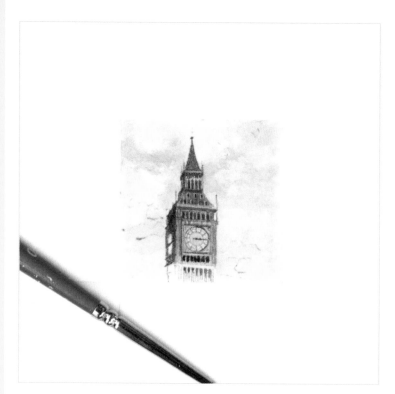

STEP 4

Continue working your way down the building with general color, while maintaining details. Add highlights on the windows with white gouache.

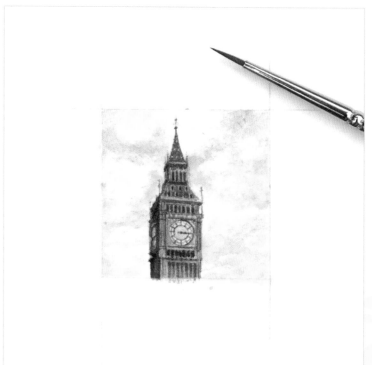

STEP 5

Finish adding color to the building, and then apply another pass of darks to the shadow areas. Create more depth in the clouds with a very light wash of yellow ochre on those closest to the horizon.

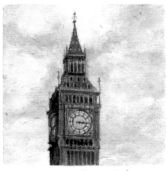

Karen Libecap

STEP 6

Remove the tape and erase the pencil lines. Add one final pass of white to the lighter areas of the clouds to finish.

GALLERY

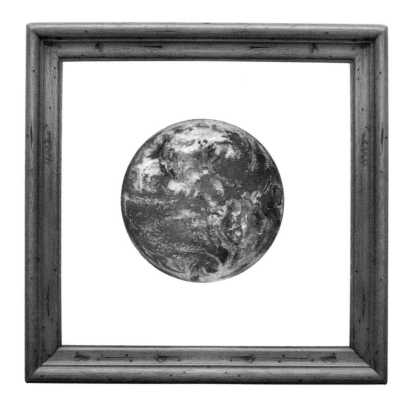

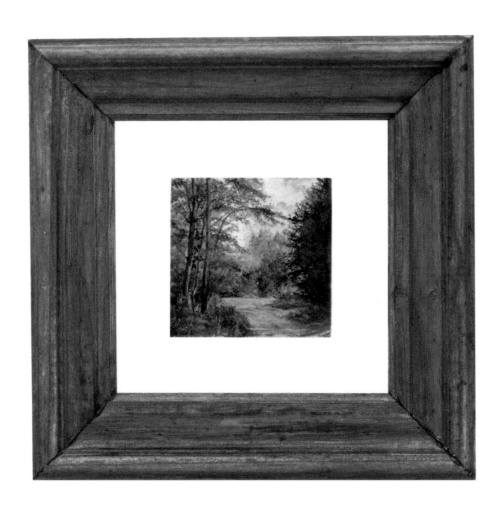

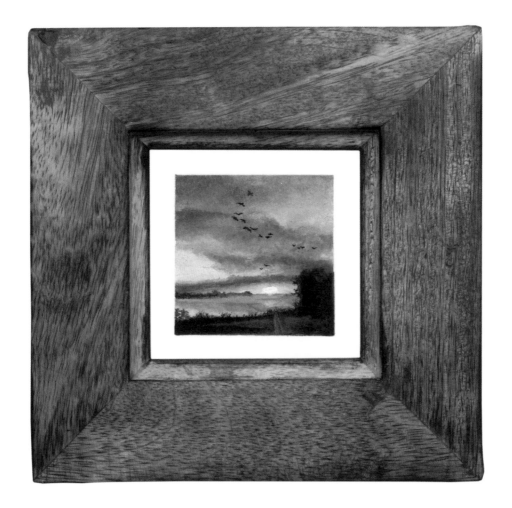

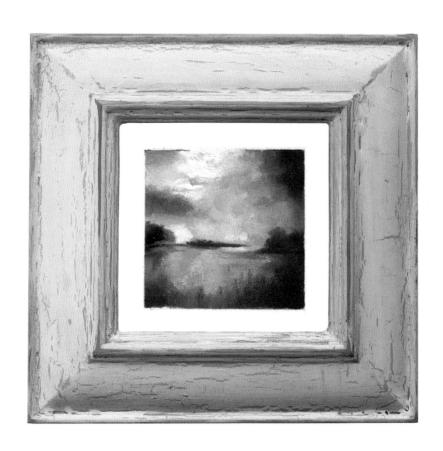

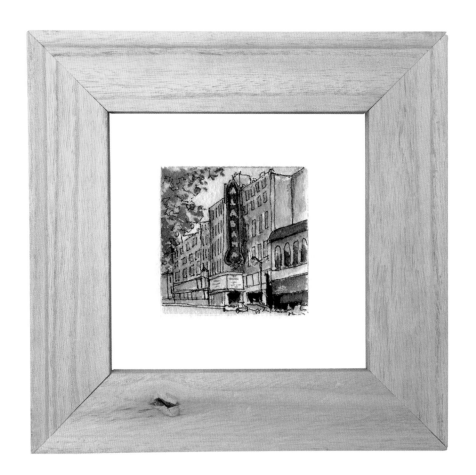

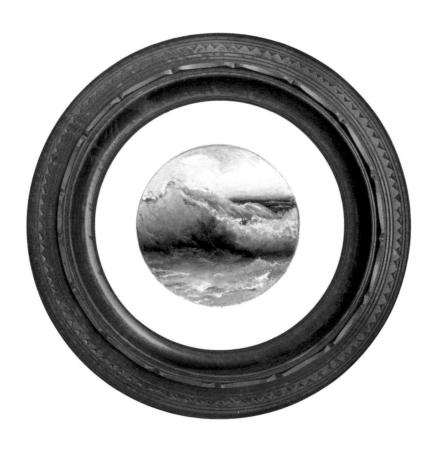

NIGHT SKY CONSTELLATIONS

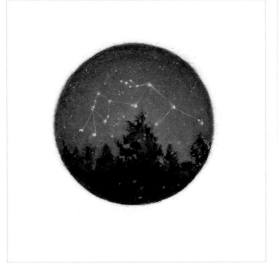

Aquarius

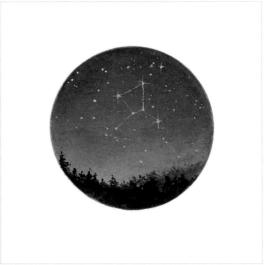

Cancer

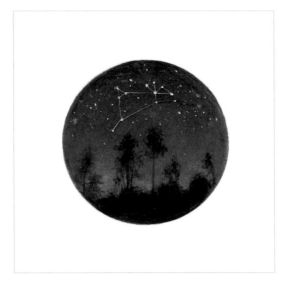

Taurus

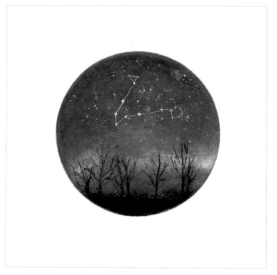

Virgo

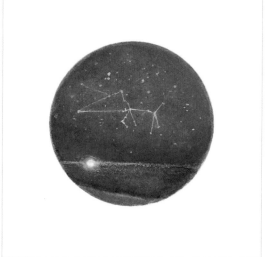

Capricorn

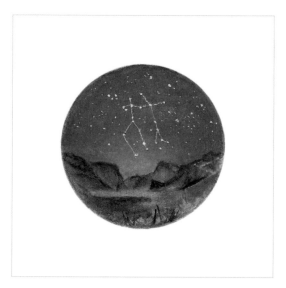

Gemini

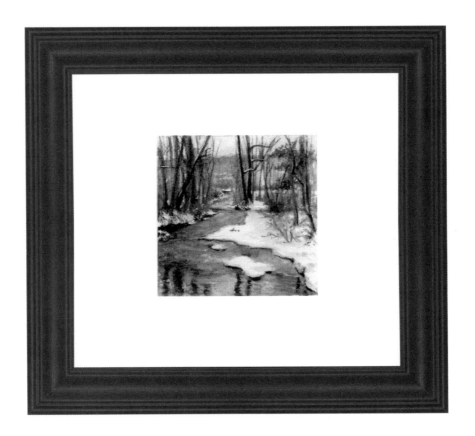

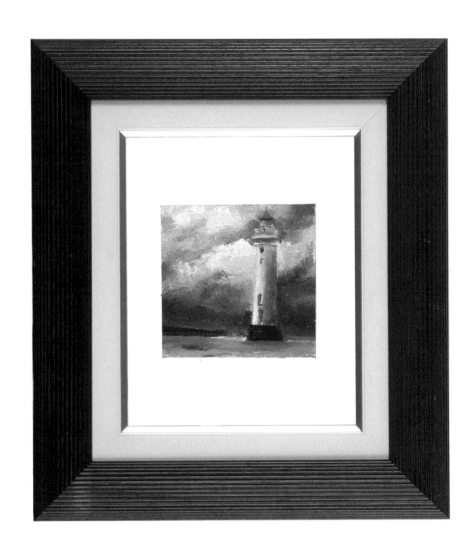

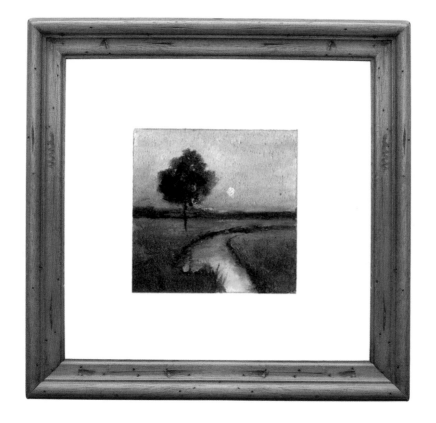

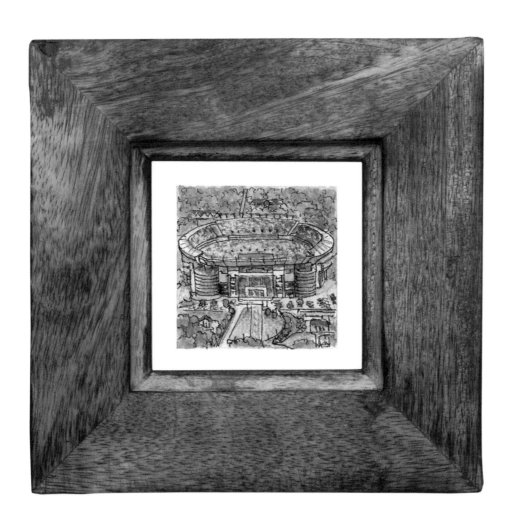

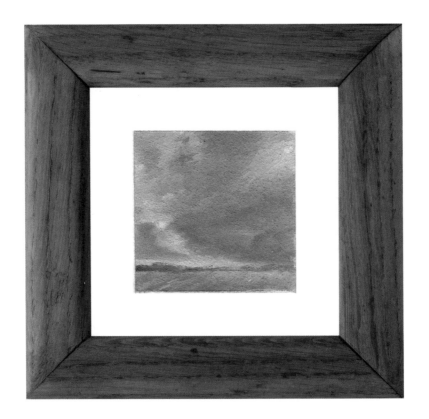

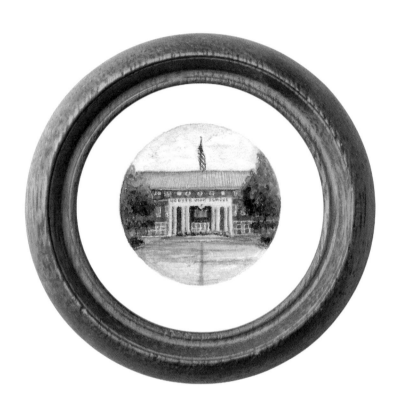

TINY PLACES SKETCHBOOK

Use these squares and practice areas to draw the step-by-step projects in this section or to create some of your favorite places—real or imaginary!

ABOUT THE ARTIST

KAREN LIBECAP has been making art for more than 35 years and has been surrounded by artists throughout her life. Her mother, an oil painter and sculptor, encouraged her to pursue her passion. Karen earned a degree in graphic design from Kent State University and has worked as an art director in major cities such as Chicago, Cincinnati, and Columbus, Ohio.

Karen has always been in awe of the colors and shapes that surround her, and her work ranges from photorealistic to painterly. Karen has worked in many different mediums, including watercolor, acrylics, clay, and wax, but she always feels at home with pastels and oils.

To view more of Karen's tiny art, visit www.etsy.com/shop/KarenLibecap.